D1408469

BETHLEHEM
PENNSYLVANIA

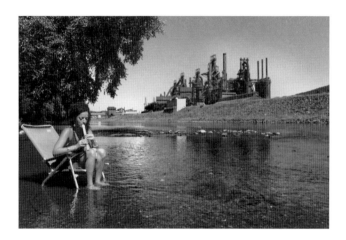

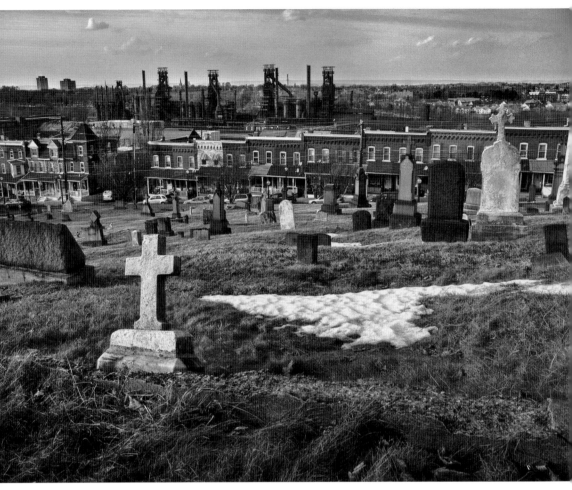

St. Michael's Cemetery
The cemetery, established in 1867 on land donated by Asa Packer, belongs to the Holy Infancy parish. The interred represent at least 26 nationalities. Volunteers such as Amey Senape, Dan Gasda, Al Barron, and the South Bethlehem Historical Society have worked tirelessly to keep the cemetery from becoming overgrown. (Courtesy Frank T. Smith.)

Page 1: In the Shadow of Bethlehem Steel
Until the last blast furnace was shut down in 1995, Bethlehem Steel Corporation seemed to touch every aspect of the lives of Bethlehem residents. Erica Izor plays her flute, enjoying the peaceful Lehigh River, with the old blast furnaces in the background. (Courtesy Amber Ott.)

LEGENDARY LOCALS

OF

BETHLEHEM

PENNSYLVANIA

KAREN M. SAMUELS

LEGENDARY
LOCALS

Legendary Locals is an imprint of Arcadia Publishing
Charleston, South Carolina

Printed in the United States of America

Library of Congress Control Number: 2013930313

For all general information, please contact Arcadia Publishing:
Telephone 843-853-2070
Fax 843-853-0044
E-mail sales@arcadiapublishing.com
For customer service and orders:
Toll-Free 1-888-313-2665

Visit us on the Internet at www.arcadiapublishing.com

On the Front Cover: Clockwise from top left:
Catherine Bowen Price, writer (Courtesy of the Samuels Collection; see page 19); Ethelbert Talbot, Episcopal bishop (Courtesy of the Moravian Archives, Bethlehem; see page 88); John Henry Kilbuck, missionary (Courtesy of the Moravian Archives, Bethlehem; see page 91); Henrietta Benigna Justine Zinzendorf von Watteville, countess (Courtesy of the Moravian Archives, Bethlehem; see page 12); Marlene "Linny" Fowler, artist and heiress (Courtesy of Bob Miller; see page 95); William Emile Doster, lawyer (Courtesy of the Moravian Archives, Bethlehem; see page 109); Joan B. Campion, writer and historian (Courtesy of the Arner family; see page 26); Benjamin Rice, first African American resident (Courtesy of the Moravian Archives, Bethlehem; see page 101); Mary Augusta Yohe, actress (Courtesy of the Samuels Collection; see page 59).

On the Back Cover: From left to right:
Mary Elvira Strunk (far right), missionary (Courtesy of the Samuels Collection, see page 90); Jedidiah Weiss, musician (Courtesy of the Moravian Archives, Bethlehem, see page 58).

CONTENTS

ACKNOWLEDGMENTS

The author gratefully acknowledges the work of all prior historians of Bethlehem, whose efforts serve as a foundation for this volume. For sharing their personal photographs for this project, I thank Amey Senape and Mike Kramer, Frank T. Smith, Julia Maserjian, Roger J. Hudak, the Arner Family, Deborah Courville, Amber Ott, Jack M. Berk, Jane K. Gill, Timothy Herd, David Bressoud, Lorna Velazquez, Lupe Pearce, Alan L. Jennings, Steve Kimock, Ken Raniere, Graham P. Stanford, Christine Ussler, Felicia Gruver, Gelsey Kirkland, Bill White, Jimmy DeGrasso, Thom Schuyler, Ramona LaBarre, Dave Fry, Lynn Olanoff, Marion Andretti, Rabbi Allen Juda, Bob Miller, Joe Conn, Frank V. Loretti, Faith House Manhattan, Michael Adams, Sandra Aguilar, Hugo Ceron, Ellie Deardorff, Meghan Elliott, Ryan Salmon, Dom Tilbaldo, the Mickolay family, and Jerry Green.

This book could not have begun without Paul Peucker and the Moravian Archives in Bethlehem. Mr. Peucker is the director and archivist of one of the most valuable collections related to early American history, including firsthand documents, paintings, photographs, and books. Peucker has been exceedingly generous with his time for this project, as he is with all researchers and students. Dana Grubb was invaluable to the project, with his knowledge of local politics and of all the wonderful individuals in Bethlehem who made a real difference in our lives over the years. Also, I was so grateful to Dom Tilbaldo, who walked to Nutley City Hall from his home specifically to take a photograph of Emil Ditbitsch. Ryan Salmon made a similar trip to a library in Minnesota for a rare photograph of C.A.P. Turner. Thanks go to my editor, Erin L. Vosgien, who made this a great experience, and my eternal gratitude goes to my history buddies, Lee Weiner, Ann Marie Gonsalves, Ken Raniere, and Barbara Hausman. Finally, I am thankful for the support from my husband, John, and sons, Teddy and Tommy.

FOREWORD

In this book, Karen Samuels presents the history of Bethlehem through the lives and portraits of its residents. Throughout its history, many interesting people have lived in Bethlehem, citizens whose significance often reached far beyond the Lehigh Valley: craftsmen, teachers, musicians, ministers, managers, and mayors. When reading about the lives of these people, we learn that Bethlehem has been a diverse city from its very beginning: Europeans, American Indians, and African Americans have lived and worked here together since the 1740s. Bethlehem residents have always had a strong sense of community. For the first 20 years, the founding generation formed a common household, the General Economy. Everyone worked for the common good and received food, lodging, and clothing in return. Above all, they experienced fellowship.

The Moravian founders of Bethlehem encouraged each member to write what they called a *Lebenslauf*, a testimony of one's walk through life. The *Lebenslauf* was read as a last farewell at the funeral service of that person. In a similar way, Karen Samuels presents the biographies and portraits of 216 Bethlehem residents throughout the centuries, and she allows them to speak to the reader.

The Moravian Church dominated life in this town until the community opened up in the middle of the 19th century and others were able to join. The community of Bethlehem now stretched to the south side of the Lehigh River, and life in Bethlehem quickly became Americanized. But Bethlehem never became like other American cities. This was because of the unique people who continued to live here. These are the lives and faces of those people.

—Paul Peucker
Archivist of the Moravian Church, Northern Province

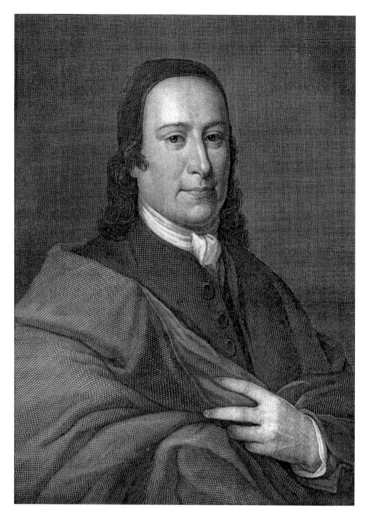

Count Nicholas Ludwig von Zinzendorf

Nicholas Ludwig, Count of Zinzendorf and Pottendurf (Germany), was born on May 25, 1700, in Dresden. He was a devout pietist, a talented orator, and wrote a large number of hymns. Zinzendorf studied law at the University of Wittenberg. He married Erdmuth Dorothea Reuss in 1724. The couple agreed to form a *Streiterehe* (a marriage in battle for Christ). The Zinzendorfs began their marriage at their Berthelsdorf (Herrnhut) estate, which Zinzendorf had recently purchased from his grandmother. Between the years of 1724 and 1740, the Zinzendorfs had 12 children, with only four living to adulthood. The year he purchased his estate, Zinzendorf was approached by a group of Moravian refugees (known as Unitas Fratrum) who requested permission to establish a community on his land. Zinzendorf granted his consent and became engaged in their cause. He looked upon the beliefs of his tenants as a renewal of the Lutheran religion. He was named a Moravian bishop in 1737 and devoted the rest of his life to establishing Moravian settlements and sending missionaries around the world, including to the West Indies, Greenland, and North America. Zinzendorf arrived at the new Pennsylvania settlement on the Lehigh River on December 21, 1741. He was accompanied by his oldest daughter, the Countess Benigna. At a service on December 14, Zinzendorf named the village "Bethlehem." In 1756, Erdmuth became ill with a cold and died at age 55. A year later, Anna Nitschmann became the wife of Zinzendorf. They were married for three years and died within two weeks of each other in 1760. Zinzendorf and his two wives are buried side by side in God's Acre in Herrnhut. (Courtesy of the Moravian Archives, Bethlehem.)

INTRODUCTION

In 1722, an act of kindness eventually led to the settlement of Bethlehem. A group of Protestant refugees from Moravia, followers of the Bohemian-born Jan Hus (1369–1415), left their homes, in an area known today as the Czech Republic. Escaping religious persecution from the Catholic Reformation, they made their way to Germany where they fortuitously met Count Ludwig von Zinzendorf. He invited the group to settle on his estate in Saxony and took on the role of their leader and protector. It is here that they founded the community of Herrnhut, soon to become the center of a dynamic Christian movement, attracting people from different parts of Germany and Europe. A decade later, the Moravians sent the first of their missionaries to Christianize nonbelievers. In 1741, Zinzendorf purchased a 500-acre tract of land, at the junction of the Monocacy Creek and the Lehigh River, which would become Bethlehem, the center of the American missionary enterprise. For the first 20 years of the fledgling settlement, the Moravians organized themselves into a commune to accomplish the goal of supporting their missionaries. Under the efficient and adroit leadership of Bishop Augustus G. Spangenberg, they established several farms and 32 industries by 1749. Historians attribute the remarkable success of their colonial industries to the united effort of the Moravians toward this one goal. Bishop Peter Boehler was one of the Moravian missionaries sent to America to preach to the Native Americans. When Spangenberg was called back to Germany, Boehler became an indispensable administrator of the American settlements. In the early 1770s, the missionaries David Zeisberger and John Heckewelder established the Christian Lenape villages of Schoenbrunn, Gnadenhutten, and Lichtenau in eastern Ohio. The accounts of their experiences living among Lenape, Mohawk, and Iroquois informed several books and movies.

Industry was only one of the exceptional achievements of the Moravians in early Bethlehem. Henrietta Benigna Justine Zinzendorf von Watteville (1725–1789), daughter of Count von Zinzendorf and his wife, Countess Erdmuth Dorothea von Reuss, at age 16, opened America's first boarding school for girls in Germantown, Pennsylvania. The school was established in 1742, then moved a few weeks later to Bethlehem. Benigna invited girls, independent of religion, race, or ethnicity, to attend. What made this school exceptional was that it existed in a frontier town and yet offered knowledgeable teachers to educate the girls in the subjects of English, German, mathematics, geography, history, and botany. The school continued to flourish and gained a highly regarded reputation. It remained open through several stressful periods, such as the French and Indian War, the Revolutionary War, and the Civil War. The girls' school became Moravian Seminary and College for Women in 1913. A boys' school was opened in Bethlehem around 1742. This school moved to Nazareth in 1759, and an extension of the school became a men's college and theological seminary in 1807. The Moravian College and Theological Seminary moved back to Bethlehem in 1892. In 1954, the two single-sex schools combined to form the single, coeducational, modern institution of Moravian College. Moravian Academy continues the tradition of offering K-12 education.

Music was an important part of daily life in early Bethlehem. Hymns and brass ensembles served specific ceremonial functions. The Moravian church leaders encouraged expertise in stringed instruments, organs, pianos, and wind instruments. Moravian missionaries carried their knowledge of this music deep into the wilderness of America. The Bethlehem Collegium Musicum (the first symphony orchestra in America, established in 1744) was playing the music of the best composers of the day. Music by the Stamitzes, Haydn, Mozart, and the Bach family could be heard on the streets of Bethlehem long before it was heard in Philadelphia, New York City, or Boston. Moravians themselves also composed America's earliest chamber music, anthems, solos, and duets for voice.

As the sun was setting on Bethlehem on August 9, 1814, a crudely built ship, called an ark, was floating by on the Lehigh River. Its cargo would bring great change to Bethlehem. The ark contained 24 tons of "black diamonds," or anthracite coal, from the Room Run Mine in Carbon County. In 1829, the Lehigh Canal was completed, allowing for steady traffic of boats carrying anthracite coal to Philadelphia. The canal brought an increase in population and economic opportunities to Bethlehem. However, it also brought non-Moravians to the town. At this time, the grandsons of the original Moravian families were in charge of Bethlehem, and the majority of them believed that conducting business with outsiders would bring prosperity to Bethlehem.

Asa Packer, a wealthy canal boatyard operator, construction contractor, and coal-mine owner, saw the railroad as an improvement over the canal system. When the canals froze in winter, they were unusable. In 1852, he bought up the majority of the stock in the Delaware, Lehigh, Schuylkill & Susquehanna Railroad (DLS&S) and provided the leadership to make it a successful operation. He hired 29-year-old Robert H. Sayre as the chief engineer. Sayre surveyed along the Lehigh River, from Jim Thorpe to Easton, to lay a single track of 46 miles. Packer began blasting limestone bluffs between Bethlehem and Easton. Around this time, DLS&S changed its name to the Lehigh Valley Railroad. In Easton, the Lehigh Valley Railroad met up with the Belvedere, Delaware, and Central Railroad of New Jersey. These railroads offered access to Philadelphia and New York.

Once the railroad was in place, manufacturers, attracted to the natural resources of the Lehigh Valley, began building plants nearby. In 1853, Samuel Wetherill erected zinc oxide furnaces on the south side of the Lehigh River for his Pennsylvania & Lehigh Zinc Company. Within the year, Joseph Wharton, his brother Charles, and associates bought the controlling interest in the company. In 1863, the Bethlehem Iron Company completed its first blast furnace and rolling mill next door. Then, 10 years later, the enterprise was the first in the United States to use the Bessemer system to produce steel. In 1889, Bethlehem Iron Company accepted contracts from the US Navy. The company was reorganized as the Bethlehem Steel Company, with Charles M. Schwab as the president, in 1904.

Bethlehem Steel Corporation became the second-largest producer of steel in the United States. It produced metal products vital to the government during the Civil War, Spanish American War, World War I, and World War II. The company had more than 30,000 employees on its rolls during World War II. New immigrants from at least 50 different nations and ethnic groups filled most of the jobs. Management and employees alike believed that Bethlehem Steel was invincible and that their sons and daughters were guaranteed a steady wage. When people had money to spend, other enterprises sprung up. This period also saw the construction of modern houses, new schools, movie theaters, restaurants, and the luxurious Hotel Bethlehem. However, in 1998, it all came to an end. Experts blamed high labor costs, poor long-term planning on the part of management, and foreign competition for the closure of the once-great corporation.

Today, the largest employer in Bethlehem is St. Luke's Hospital, followed by Lehigh University, local grocery stores, and the Sands Casino Resort. Bethlehem residents survived the fall of Bethlehem Steel by finding service industry jobs. The city brings in tourist dollars through the Colonial Industrial Quarter, Moravian Book Shop, Christmas light displays, Bach Music Festival, Sands Casino Resort, and ArtsQuest's SteelStacks, which runs Christkindlmarkt (a holiday marketplace in December) and Musikfest (a music festival in August).

This book takes on the difficult task of selecting legends from the countless worthy people who have had an impact on the enlightenment, commercial growth, and human condition in Bethlehem. These legends have set high standards for the rest of us, and we rejoice that they called Bethlehem "home."

CHAPTER ONE

The Heroes of Education

In the 18th century, the education of children was not a priority to all Pennsylvania settlers. The critical aspect of life was survival. In fact, schooling, when it did take place, was restricted to those few months in the winter when the farmlands lay dormant.

The quality of education offered in Bethlehem was the exception. The Moravian founders believed that the education of both sexes was an important aspect of their faith. The Bethlehem Area School District was formed with the passage of the Pennsylvania Common School Act in 1836. The town of Bethlehem, already possessing strong educational institutions, accommodated the new act by converting its existing schools into public schools. A public school board was elected, made up of the same individuals who had served on the board for the Moravian private schools. The Bethlehem Area School District was officially approved by the state legislature in 1836. When Bethlehem incorporated into a borough in 1845, public school children were given separate instruction.

In 1853, the first public school was built on Wall Street. By 1859, there were 225 students attending the school. The Penrose School, built in 1869 on Vine Street, was named for Sen. Boies Penrose. It provided the first high school program in 1874. In 1883, Bethlehem public education was under the direction of its first district superintendent, George H. Desh.

In 1918, the three boroughs of Bethlehem, South Bethlehem, and West Bethlehem consolidated. These three public school boards transitioned into one within a few years. In 1965, Bethlehem School District consolidated with Bethlehem Township, Hanover Township, Fountain Hill, and Freemansburg. In 1970, the Bethlehem Area Vocational Technical School opened to serve Bethlehem, Northampton, and Saucon Valley School Districts. Today, Dr. Joseph J. Roy, the superintendent of Bethlehem's public schools, oversees the continuous upgrading of 22 school buildings and curriculum for over 15,000 students.

Henrietta Benigna Justine Zinzendorf von Watteville

Benigna (1725–1789) was born in Berthelsdorf, Saxony (Germany) to Count Nicolaus Ludwig von Zinzendorf and his wife, Countess Erdmuthe Dorothea von Reuss. She traveled with her father throughout Europe, New York, and Pennsylvania to visit Moravian missions. In 1742, the 16-year-old countess founded the first girls' boarding school in America. The school gained an excellent reputation. In 1746, Benigna married Baron Johann de Watteville, her father's secretary, in a ceremony performed by Zinzendorf himself. The couple traveled to and supervised Moravian missions, and they had four children. (Courtesy of the Moravian Archives, Bethlehem.)

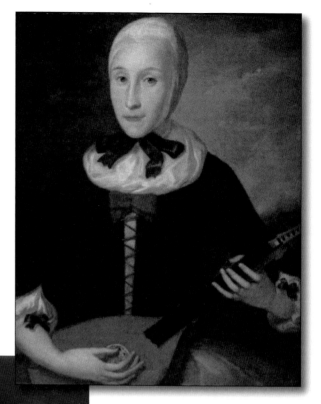

George Neisser

Neisser (1715–1784) was born in Sehlen, Germany. His parents moved the family to Herrnhut in 1723. Neisser joined the expedition to Georgia in 1735 to establish the first Moravian settlement in America. He was indispensable in the settlement of Bethlehem. Neisser kept the first daily diary in 1742 and was the secretary of the community. He was also the first postmaster and the schoolmaster of the Female Seminary. In 1745, he married Catherine Theodora Medter. Neisser was ordained a deacon in 1748 and served several congregations until his death in Philadelphia. (Courtesy of the Moravian Archives, Bethlehem.)

John Christopher Pyrlaeus
Pyrlaeus (1713–1785) was born in Pansa, Germany, into a family of three generations of Lutheran pastors. He graduated from Leipsic University and in 1738 visited Herrnhut to join the Moravian community. Pyrlaeus arrived in Bethlehem in 1741 and founded the Bethlehem Collegium Musicum. He learned the Mohawk language from Conrad Weiser and taught it to missionaries. Pyrlaeus served as a missionary himself from 1744 to 1751. He married Susan Benezet in 1742, and the couple had six children. He traveled with his wife to England in 1751, eventually returning to Herrnhut. (Courtesy of the Moravian Archives, Bethlehem.)

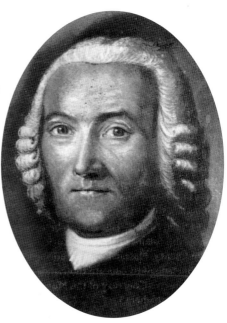

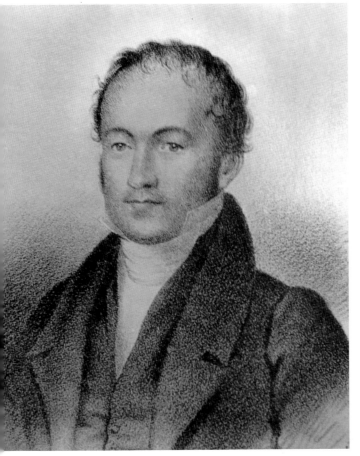

Lewis David de Schweinitz
Schweinitz (1780–1834), a descendent of Count Zinzendorf, was born in Bethlehem. He attended the theological seminary at Niesky, Prussia, in 1798. He was the first American to receive a doctorate of philosophy. Through his extensive work in collecting and categorizing fungi, he became known as the "Father of North American Mycology." He married Louisa Amelia Ledoux in 1812, and they had four sons, all of whom became prominent ministers in the Moravian Church. (Courtesy of the Moravian Archives, Bethlehem.)

13

Mary Catherine "Polly" Blum
Blum (1785–1885) was born in the Moravian settlement of Hope, New Jersey. She moved with her family to Bethlehem in 1808. Blum was enrolled in the Bethlehem Seminary and, upon graduation, stayed on as a teacher. In 1818, she introduced to the curriculum needlework done in crepe and ribbon. She presented a gift of needlepoint from the school to the wife of Pres. John Adams. This gift can be seen today at the Adams National Historic Park in Quincy, Massachusetts. Retiring in 1842, she helped to educate thousands of young women. (Courtesy of the Moravian Archives, Bethlehem.)

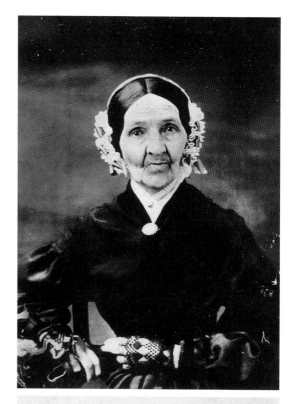

Sylvester Wolle
Wolle (1816–1873) was a teacher, pastor, presbyter, and principal of the Moravian Young Ladies Seminary. He was born in Jacobsburg, Pennsylvania. During the Civil War, Wolle allowed students from the South to remain at the school for safety, even without payment of tuition. As principal, he hired the best instrumentalists and vocalists from Europe to instruct the students. He married Sarah Caroline Rice in 1839, and they had two daughters. (Courtesy of the Moravian Archives, Bethlehem.)

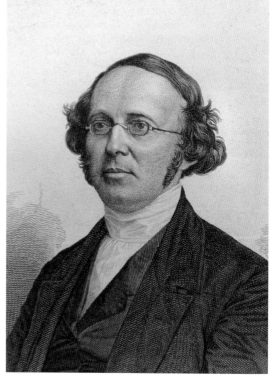

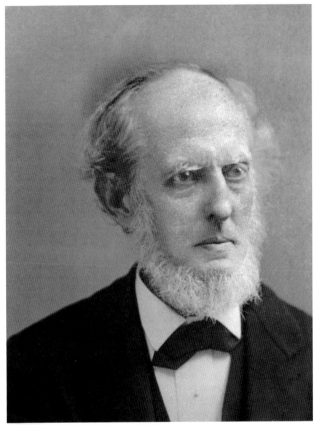

Francis Wolle
Wolle (1817–1893), born in Jacobsburg, Pennsylvania, invented the first machine to make paper bags. By 1860, his company, the Union Bag Machine Company, was producing the majority of paper bags used in the United States. He also was a botanist, teacher, principal of the Moravian Young Ladies Seminary, and a clergyman. In 1848, he married Elizabeth Weiss Seidel, a widow. She had a daughter from her first marriage and four children with Wolle. (Courtesy of the Moravian Archives, Bethlehem.)

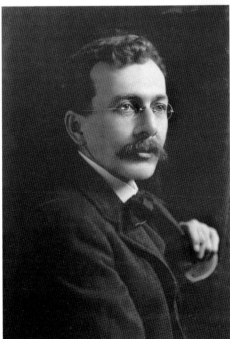

John Frederick Wolle
Fred Wolle (1863–1933) was born in Bethlehem and inherited great musical ability from his Wolle and Weis ancestors. As his father, Francis Wolle, was the principal of the Moravian Seminary for Girls, Fred grew up in the school. In 1884, he traveled to Munich to study at the Royal Conservatory of Music. When he returned, Wolle was determined to introduce Bach's music to the community of Bethlehem. He established the Bach Choir in 1900. The group has played in Carnegie Hall, London's Royal Albert Hall, and the Kennedy Center. He married Jean Creveling Stryker in 1886. Their daughter, Gretchen, was born in 1893. Fred continued to conduct the Bach Choir until his death in 1933. (Courtesy of the Moravian Archives, Bethlehem.)

Henry Coppee
Coppee was born in Savannah, Georgia, and attended Yale University and the US Military Academy at West Point. He served in the Mexican-American War as a lieutenant, and was a professor of English at West Point and the University of Pennsylvania. Coppee (1821–1895) was the first president of Lehigh University, from 1866 to 1875. He authored several books, including biographies and textbooks, and served on the board of regents for the Smithsonian Institution from 1864 until his death. Coppee married Julia DeWitt in 1848, and they raised their three daughters in Bethlehem. (Courtesy of the Moravian Archives, Bethlehem.)

Henry Sturgis Drinker
Drinker (1850–1937) was born in Hong Kong, where he lived for the first eight years of his life. His father, Sandwith Drinker, was an international businessman. Henry was an 1871 Lehigh graduate and the only alumnus to become president of Lehigh. Drinker helped to engineer the two-mile-long Musconetcong Tunnel, which made railroad travel possible between Easton, Pennsylvania, and New York City. He was solicitor general for the railroad for 20 years before accepting the presidency of Lehigh in 1905. Drinker married Aimee Ernesta Beaux in 1879, and they had five children. (Courtesy of the Moravian Archives, Bethlehem.)

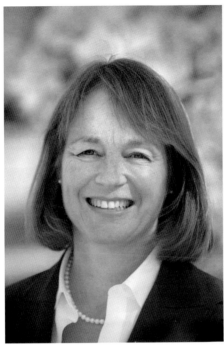

Alice P. Gast
Gast was born in 1958 in Houston, Texas, and attended the University of Southern California and Princeton University. She is an internationally renowned scholar, researcher, and academic leader. From 1985 to 2001, she taught at Stanford University, and then served as the vice president for research and associate provost at the Massachusetts Institute of Technology until her appointment to Lehigh University as its 13th president, in 2006. She was the first woman appointed to this position. Gast was named one of the top 100 "Modern Era" engineers in the country, under the category of "Leadership," by the American Institute of Chemical Engineers. (Courtesy of Lehigh University.)

Lawrence Henry Gipson
Gipson, a native of Greeley, Colorado, was a Pulitzer Prize–winning historian and one of the most distinguished scholars in US history. He was a Rhodes scholar and attended Yale University. In 1909, Gipson married Jeannette Reed, a teacher from Sioux City, Iowa. In 1924, Gipson (1880–1971) was appointed professor of history at Lehigh University, a position he held until his death. During his years at Lehigh, he wrote the 15-volume series *The British Empire Before the American Revolution*, completing the final volume shortly before his death. (Courtesy of Lehigh University.)

W. Ross Yates

Yates was born in Corvallis, Oregon, and now spends his retirement years in McMinnville, Oregon. He attended the University of Oregon and Yale University. At Lehigh University, Yates served on the faculty and in the position of dean of the College of Arts and Sciences for 31 years. He wrote and edited several important books on local history, including *Joseph Wharton: Quaker Industrial Pioneer* (1988) and *Lehigh University: A History of Education in Engineering, Business, and the Human Condition* (1992). (Courtesy of Lehigh University.)

Lynn S. Beedle

Beedle (1917–2003) was an American structural engineer and the founder and director of the Council on Tall Buildings and Urban Habitat at Lehigh. He was notable for his design and building of skyscrapers. Born in Orland, California, in 1917, he attended the University of California, Berkley. When he saw the opening of the Golden Gate Bridge in 1937, he decided to concentrate on civil engineering. During World War II, he was recruited by the Navy to perform underwater explosion research at the Norfolk Shipyard in Virginia. He arrived at Lehigh University in 1947 as an instructor and to complete his PhD. In 2003, Beedle died in Hellertown of pancreatic cancer. (Courtesy of Lehigh University.)

Julia Maserjian

A historian, Maserjian specializes in digital humanities projects. She has curated and contributed to educational websites such as Lehigh University Beyond Steel: An Archive of Lehigh Valley Industry and Culture, the Bethlehem Area Public Library, and Moravian College Bethlehem Digital History Project. She takes a multimedia approach to informing the public about history, using video, photographs, documents, oral histories, and geographic information systems. Maserjian has facilitated several community discussions in Bethlehem about historical preservation and free speech. (Courtesy of Julia Maserjian.)

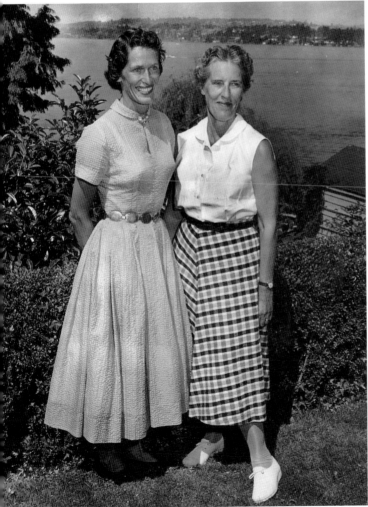

Catherine Drinker Bowen

Bowen (1897–1973) was born in Haverford, Pennsylvania, and moved with her family to Bethlehem. She wrote about growing up on the Lehigh University campus as the daughter of the president, Henry S. Drinker, in her book *Family Portrait* (1970). She attended the Juilliard School in New York City for the violin. In 1919, she married Ezra Bowen, a professor of economics at Lehigh, and they had two children. Prince became famous for her biographies. She is seen here on the right with her daughter, Catherine Bowen Prince. (Courtesy of the Samuels Collection.)

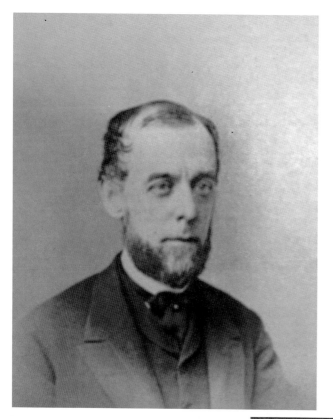

William C. Reichel

Reichel (1824–1876) was born in Salem, North Carolina, to a family devoted for six generations before him to the Moravian religion. He graduated from the Moravian Theological Seminary in 1844 and became a professor there. Reichel later taught Latin and natural sciences at the Young Ladies' Seminary. He was a gifted teacher, researcher, artist, linguist, author, and historian. Reichel, a presbyter of the Moravian Church, did more than anyone else to illuminate the early history of the Moravian Church in the United States. He wrote several articles and books on local history, including *The Crown Inn, near Bethlehem, Penna.* (1872) and *The Old Sun Inn, at Bethlehem, Penna.* (1873). (Courtesy of the Moravian Archives, Bethlehem.)

Edwin Joseph Heath

Heath was born in 1880 at the Moravian Parsonage in St. John, Virgin Islands, West Indies. He graduated from Moravian College and Theological Seminary in 1907, and was ordained and became a missionary in Trinidad and Antigua. Heath (1880–1953) served as head of the history department at Salem Academy and College in Winston-Salem from 1914 to 1926, then returned to Bethlehem to become president of Moravian Seminary and College for Women from 1926 to 1949. As a Moravian missionary in Antigua, he met and married Mary Mabel Graham in 1908. They had a son and two daughters. Heath sang tenor for the Bach Choir. (Courtesy of Moravian College.)

Raymond S. Haupert
Haupert (1902–1972) was born in Watertown, Wisconsin. He graduated from Moravian College and Theological Seminary and the University of Pennsylvania and was ordained into Moravian ministry. Haupert began as a teacher at Moravian and eventually became president, serving from 1944 to 1969. He oversaw the merging of two institutions, the Moravian College and Theological Seminary and the Moravian Seminary and College for Women, in 1954. In 1932, he married Estelle Hege McCanless. They raised four children in the home they built on North Main Street in Bethlehem. Haupert received honorary degrees and numerous civic awards. (Courtesy of Moravian College.)

Christopher M. Thomforde
Thomforde was born in Cleveland, Ohio, in 1947. He attended Princeton University, Middlebury College, and Yale University Divinity School. Thomforde has served as chaplain and instructor at Colgate University and Susquehanna University and was president of Bethany College in Lindsborg, Kansas, from 1996 to 2000. He served as president of Moravian College from 2006 to 2013. During his presidency, he focused on admitting a diverse student body and oversaw several campus expansions. He married Kathy Gardner Chadwick, an author and college professor. They have five children. (Courtesy of St. Olaf College.)

Jeanette Barres Zug
Zug (1907–1994) was born in Bethlehem and graduated from Moravian Preparatory School in 1924 and Wellesley College in 1928. As a result of her efforts, the historic Moravian museum tours began in the 1930s. Zug was instrumental in starting the Moravian Historical Museum in 1938. The museum began in the Moravian's Sisters House, but became so popular that it was moved to the Gemein Haus in 1966. Zug authored several historical publications and served as coordinator for the editorial committee of the *Bethlehem of Pennsylvania* editions. She was a past director of Historic Bethlehem Inc. She married Charles Keller Zug Jr. in 1929, and they had a daughter and three sons. (Courtesy of the Historic Bethlehem Partnership.)

Ralph Grayson Schwarz
Schwarz was born in Rutherford, New Jersey, in 1926. After service in the Army, he attended Lehigh University. While working for the Bethlehem Steel Corporation (1949–1961) as an engineer, Schwarz organized Historic Bethlehem Inc. and the Annie S. Kemerer Museum. He volunteered his time as a consultant and authority on architecture, planning, development, and preservation on every historical organization board in Bethlehem. He wrote the books *Bethlehem on the Lehigh* (1991), *Moravian Bethlehem* (1993), *Bach in Bethlehem* (1998), and *Saucon Valley Country Club: An American Legacy, 1920–2000* (2000). (Courtesy of the Historic Bethlehem Partnership.)

Nina G. Bushnell
Bushnell (1881–1970) was dean of women at Moravian College in Bethlehem and, earlier, at the University of Mary Washington in Fredericksburg, Virginia. A building is named for her at Mary Washington. Moravian College alumni still remember the teas she organized to induct the students into the traditions of a high tea. Bushnell assisted in the transition of the college to coeducational status in 1954. She was a beloved authority figure, strict but caring. (Courtesy of the Samuels Collection.)

Elizabeth Lehman Myers
Myers, a native of Bethlehem, married Jacob Upton Myers, son of a prominent Bethlehem family, in 1900. She was the city historian for Bethlehem and the historian for the Moravian Seminary and College for Women. Myers (1869–1936) dedicated her life to the study of Moravian history. She wrote *A Century of Moravian Sisters* (1918) and *History of the Bethlehem Pike* (1925). Her son, Richmond Myers, followed in her footsteps and wrote many highly regarded books on Bethlehem history. (Courtesy of the Moravian Archives, Bethlehem.)

Vernon H. Nelson
Nelson served as archivist of the Moravian Church in Bethlehem for more than 40 years (1960–2004). He wrote the biography of Moravian painter John Valentine Haidt, which was published postmortem. Nelson was born in Sturgeon Bay, Wisconsin, and attended the University of Wisconsin (graduating in 1955), Moravian Theological Seminary (graduating in 1958), and the University of Pennsylvania (graduating in 1967). Nelson (1933–2010) oversaw the compilation of an index to the Gemein-Nachrichten and the move into a new archives building in 1976. He married Jane E. Jordan, and they had two daughters. (Courtesy of the Moravian Archives, Bethlehem.)

Roger John Hudak
Hudak was born in Bethlehem in 1943 and graduated from Liberty High School in 1961 and Moravian College in 1965. He was an English teacher at Pennridge Central Junior High School and at Liberty High School. For 28 years, Hudak was an advisor to *Liberty Life*, Liberty's award-winning school newspaper. Hudak was appointed chairman to the Mayor's South Side Task Force by Mayors Don Cunningham and John Callahan. He married Sandra A Bankowski in 1965. Sadly, she passed away in 2012 of complications due to diabetes. (Courtesy of Roger J. Hudak.)

Joseph Mortimer Levering

Levering (1849–1908) was born in Harrisburg, Pennsylvania. He graduated from Moravian College and Theological Seminary in 1874 and was made a deacon that year. He served Moravian churches in Ohio and Wisconsin, then moved back to Bethlehem in 1888 and was ordained a bishop. He was the provincial archivist until 1903. Levering married Martha Augusta Whitesell in 1876, and they had two daughters. He wrote the definitive book on the history of Bethlehem, *A History of Bethlehem, Pennsylvania, 1741–1892* (1903). (Courtesy of the Moravian Archives, Bethlehem.)

Hughetta Bender

Through the force of her mighty will, Bender (1906–1995) saved the Sun Inn, one of the oldest and most historically significant hostelries in the nation. She was inspired by a lecture of Rev. Vernon Nelson to found the Sun Inn Association in 1971. She raised $140,000 to purchase the property and save it from demolition. Before retiring, Bender was a laboratory technician at the Allentown State Hospital and served as dean of women at Florida Southern College, Lakeland. She was the wife of James Peter Bender and of Dr. Ernest M. Vaughn. (Courtesy of the Sun Inn Preservation Society.)

Joan B. Campion
Campion (1940–2011) was born in Lehighton and graduated from Lehighton High School in 1957 as the school's first National Merit Scholar. She graduated from Cedar Crest College in 1961. She was the author of *Mahoning: A Personal Reminiscence of Farm Life in Mahoning Valley*, and *Smokestacks and Black Diamonds: A History of Carbon County*, as well as a biography of Holocaust hero Gisi Fleischmann, *In The Lion's Mouth: Gisi Fleischmann and the Jewish Fight For Survival*. She also produced various writings on the history of Bethlehem. Campion founded the South Bethlehem Historical Society in 1985. For the last decade of her life, she wrote for the *Bethlehem Press* newspaper and for several blogs. (Courtesy of the Arner family.)

Magdalena F. Szabo
Szabo (1928–2007) was born in Bethlehem and graduated from Liberty High School in 1945. She attended Bethlehem Business School to receive training in secretarial skills. Szabo was an executive secretary for Bethlehem Contracting Company from 1954 to 1993. She served on the school board and was chairman of the South Side Task Force. Szabo was elected to city council, serving two terms. She started the first Girl Scout troop in South Terrace and was a founder of the South Bethlehem Historical Society. She traveled throughout the world, visiting countries such as Tibet, Yemen, Burma, Jordan, and China. (Courtesy of Bethlehem City Hall.)

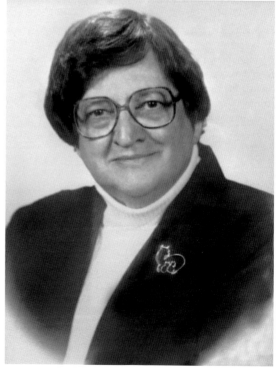

Charlene Donchez-Mowers

Donchez-Mowers was born in Bethlehem in 1947 and graduated from Arcadia University and Temple University. Before retiring in 1983, Donchez-Mowers taught advanced Spanish courses for 13 years at Octorara Area Senior High School in Atglen, Pennsylvania. She was appointed to the position of executive director of the Moravian Museum of Bethlehem in 1994. Under her direction, the group has continued the restoration of the Colonial Industrial Quarter, the reconstruction of the 1750 smithy shop, and the designation of Historic Moravian Bethlehem as a National Historic Landmark District. (Courtesy of Historic Bethlehem Partnership.)

Dana Grubb

Grubb, a lifetime resident of Bethlehem, graduated from Liberty High School in 1968 and Moravian College in 1972. He was employed by the city of Bethlehem for over 27 years, retiring in 2004 as deputy director of community development. He maintains his interest in local government by regularly attending city council meetings. Grubb is an award-winning freelance photographer for the *Bethlehem Press*, the rock group Moody Blues, and the Sands Bethlehem Event Center, and he does commercial photography. He has served on several nonprofit boards, most notably as president of the South Bethlehem Historical Society. (Courtesy of Deborah Courville.)

Jack M. Berk

Berk began his career as executive director of the Bethlehem Area Public Library in 1973. At that time, libraries dealt with primarily paper-based items. Over the next 34 years, Berk guided the library through the technological revolution, into the electronic-based 21st century. He and his outstanding staff provided the highest level of library service to the residents of the Bethlehem area, making theirs one of the best libraries in the state. In his retirement, Jack is still an avid reader and baseball fan, especially of the Ironpigs and Phillies. (Courtesy of Jack M. Berk.)

Jane Kenealy Gill

When Gill first came to Bethlehem in 1970 to attend Moravian College, she fell in love with the town: its history, its look and feel, and its sense of community. After a year away to attend library school, she returned to Bethlehem to begin a 35-year career as reference librarian at the Bethlehem Area Public Library. Those years saw vast changes in how information was delivered, as digital media replaced and enhanced paper resources. The Bethlehem Room was a special love of Gill's, building on the work of librarians going back to 1901. Gill also was a contributor to the Bethlehem Digital History Project, an award-winning website. (Courtesy of Jane Kenealy Gill.)

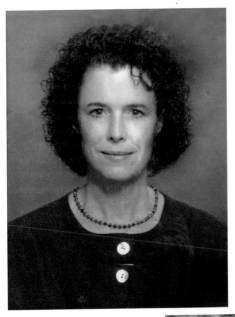

Karen D. Dolan
Dolan was born in Bordentown, New Jersey, in 1960. She is a graduate of Douglass College at Rutgers University and of Moravian College. Dolan taught English in the Bethlehem Area School District for 21 years. At Liberty High School, Dolan supervised students in restoring the condemned Illick's Mill. She has served as a member of Bethlehem City Council since 2006. Today, Dolan is the CEO and executive director of The Gertrude B. Fox Environmental Center at Illick's Mill. She is married to John Chay, and they have two sons. (Courtesy of the city of Bethlehem.)

Timothy Herd
Herd was the first recycling coordinator for Bethlehem, in 1989. He reached out to Bethlehem residents through workshops and educational literature. Under Herd's leadership, Bethlehem was one of 10 cities nationwide recognized for its recycling program by the US Conference of Mayors and the H.J. Heinz Co. National Recycling Awards. He also helped to found the Professional Recyclers of Pennsylvania, a statewide organization. Herd was born in Allentown, Pennsylvania, and has been a resident of Moore Township (Northampton County) for more than 21 years. He graduated from Penn State University. (Courtesy of Timothy Herd.)

Charles Alfred Klein
Klein (1913–1984) was principal of Liberty High School for 36 years and served a total of 46 years as an educator. As principal, he oversaw the education of 23,692 high school graduates. Klein was born in Bethlehem and attended its public schools. He graduated summa cum laude in 1935 from Muhlenberg College. In 1939, he earned his master's degree from Columbia University. Klein was voted Principal of the Year in 1977 by the Pennsylvania Association of School Principals. He was the first recipient of the award. Bethlehem Area School District dedicated a newly renovated classroom center in his honor. He married Dorothy R. Kurtz, and they had a son. (Courtesy of the Bethlehem Area School District.)

Joseph J. McIntyre
In 1939, McIntyre started his 43-year career in the Bethlehem Area School District. He was the first principal at Freedom High School, serving from 1967 to 1982. He fought to provide equal opportunities for the district's female athletes. McIntyre attended Lafayette College (graduating in 1939), the University of Pennsylvania, and Lehigh University. He served as a member of the City of Bethlehem Planning Commission for eight years. The Freedom High School gymnasium is named for him. McIntyre, a native of Bethlehem, married Mary R. "Jean" Barr. They had four children. (Courtesy of the Bethlehem Area School District.)

William J. Burkhardt
Burkhardt was born in Bethlehem in 1947. He began his teaching career at his alma mater, Liberty, in 1971, and, five years later, was named curriculum coordinator at Northeast Middle School. He returned to Bethlehem in 1982 as the assistant principal at Freedom High School. Burkhardt was back at Liberty as principal from 1990 to 2005. After his retirement, he was elected a director of the Bethlehem School Board in 2010. Burkhardt is the current co-owner of The Cup ice-cream shop. (Courtesy of the Bethlehem Area School District.)

Thomas J. Doluisio
Doluisio was born in Bethlehem. His family ran the former Homestead Restaurant in town, but he chose a career in education rather than the family business. Doluisio met his wife, Marilyn, at Penn State in 1960. As an educator for 26 years, he served in nearly every position available in the district, from principal to science teacher. In 1986, he was made superintendent and introduced several cutting-edge programs. Doluisio retired in 2002 after 52 years of serving the educational needs of the children of Bethlehem. (Courtesy of the Bethlehem Area School District.)

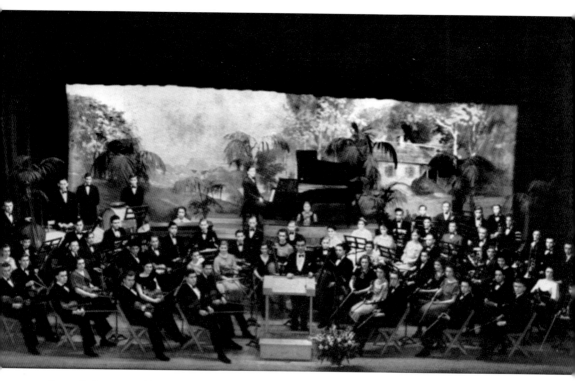

Joseph Amaruso Ricapito

Ricapito (1896–1979) was born in Bavi, Italy, and immigrated to the United States in 1913 at age 17. He settled in Bethlehem to work as a machinist for Bethlehem Steel while he supported his widower father, Dominick. He graduated from Lehigh University in 1926 and was the Liberty High School music director from 1926 to 1954. He married Anna Costellucci, and the couple had four children. The Sertoma Club of Bethlehem dedicated the Joseph Ricapito Band Shell in the Rose Garden in 1983. (Courtesy of the Bethlehem Area School District.)

Ronald P. Sherry

Sherry was born in Bethlehem and graduated from Liberty High School, West Chester State College, and Penn State University. Sherry was the director of the Liberty High School Grenadier Band from 1960 to 1991. He conceived the concept for their uniforms. Since 1991, Sherry has been the director of the Liberty High School Alumni Band. His teaching career spanned 37 years, and Sherry has won numerous awards and a key to the city of Bethlehem. (Courtesy of the Bethlehem Area School District.)

Robert J. Thompson
Thompson (1936–2010) was born in New York City and moved with his family to Bethlehem. After graduating from Amherst College (1959), he worked for the civil rights movement in the South. Thompson returned to Bethlehem to teach English at Liberty High School, but soon changed to a career as a counselor. Thompson was a cofounder of LEPOCO (Lehigh-Pocono Committee of Concern), an antiwar group, in 1965, and served on the Bethlehem School Board. Thompson married Nadine Sine, and they had three daughters. (Courtesy of the Bethlehem Area School District.)

David Bressoud
Bressoud was born in 1950 in Bethlehem and graduated from Swarthmore College in 1971. He earned his doctorate in Mathematics at Temple University in 1977 and then taught at Penn State for 17 years. He chaired the Department of Mathematics and Computer Science at Macalester College from 1995 to 2001 and is the DeWitt Wallace Professor of Mathematics. He is president of the Mathematical Association of America and has published over 50 research articles and several books in his field. Bressoud lives in Saint Paul, Minnesota, with his wife, Jan. (Courtesy of David Bressoud.)

Richard Culver

Culver was hired as the first lay principal of Bethlehem Catholic High School in 1973, after teaching math since 1965. Culver was born in Bethlehem and graduated from Liberty High School in 1961 and Moravian College in 1965. Culver said that the advantages of Catholic education were the "spirit, morality, values" offered to the students. When he retired in 2007, the school's new auditorium was named the Richard B. Culver Performing Arts Center. He and his wife, Anne Marie, have two daughters. (Courtesy of Bethlehem Catholic High School.)

Tom Maxfield

A resident of the Lehigh Valley since 1972, Maxfield is in his 25th year as an educator at Bethlehem Catholic High School, where he teaches art and structural drawing. Maxfield is also an award-winning illustrator and ceramist. He serves as an elected councilman in Lower Saucon Township and sits on Lower Saucon's planning commission and environmental advisory council. "I try to make art class at Becahi an enriching and opening experience," says Maxfield.

CHAPTER TWO

The Luminaries of Service

Many people are driven to help others and to find solutions when a great need cannot be ignored. In 1773, smallpox broke out among the children of Bethlehem. Dr. John Matthew Otto (1717–1786) asked the parents if they would permit him to try inoculation, a new and risky treatment, to contain the disease. Inoculation deliberately introduces the infection to the patient, resulting in a mild case of smallpox and a lifelong immunity to the disease. Bethlehem was an ideal community to use this treatment. The choir system allowed for the quarantine of those persons inoculated until they were out of danger of spreading the disease. The parents agreed to the inoculation of their children, which proved successful in stopping the spread of smallpox. This was 25 years before Dr. Edward Jenner developed his smallpox vaccine.

On October 17, 1873, the first patient was admitted to St. Luke's Hospital. To the credit of Bethlehem's clergy, entrepreneurs, and concerned citizens, the hospital opened in its brand-new building on Broadway in South Bethlehem. It was the first hospital in the Lehigh Valley; the nearest hospital was more than 50 miles away, in Philadelphia. At last, the local laborers who suffered railroad, mill, furnace, and mine accidents would receive immediate medical care.

A smallpox epidemic hit South Bethlehem in the spring of 1882. Strict quarantine measures were not enough to prevent more than 100 residents from dying. Employees of the Bethlehem Iron Company and the students of Lehigh University were infected. More than 80 houses were quarantined. There were so many children left orphaned that William Thurston, president of the Bethlehem Iron Company, felt compelled to build the Thurston Home for Children. Today, the organization is known as KidsPeace.

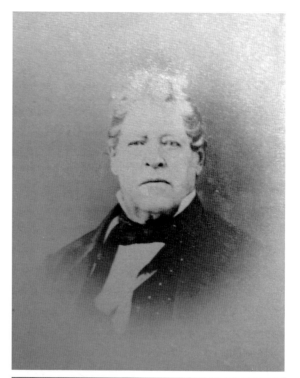

John Eberhard Freytag
Freytag (1764–1846) studied medicine at Barby and Halle, Germany. He came to Bethlehem in 1790 and for 56 years was a practicing physician and pharmacist. In the 1830s, he became a pioneer in the practice of homeopathic medicine. He was married three times. His wives were Catherine Jacobson, Christine Oliver, and Marie Salome Vetter. (Courtesy of the Moravian Archives, Bethlehem.)

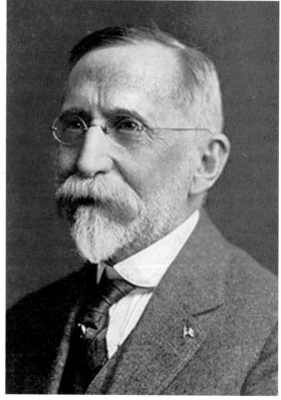

William L. Estes
Estes (1855–1940) was born on the family cotton plantation in Tennessee. He graduated from Bethel College and the University of Virginia, where he earned a medical degree. In 1881, Estes was hired as the first superintendent and chief surgeon of St. Luke's Hospital. At age 26, he transitioned St. Luke's into a modern facility. Estes established a school of nursing, the oldest degree-granting nursing school in the United States. He married Jeanne Wynne, and they raised nine children. (Courtesy of Moravian Archives, Bethlehem.)

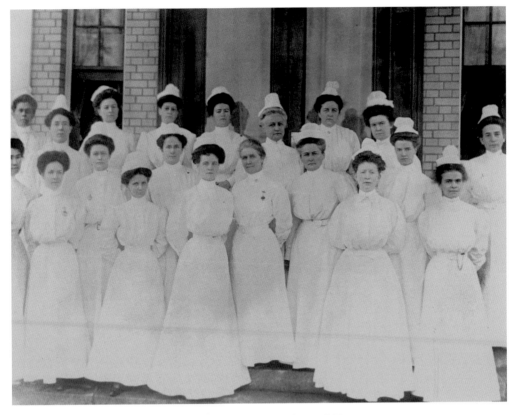

Victoria White and the Sacred Twenty

White (1858–1942) arrived at St. Luke's Hospital in 1891 and remained as the administrator of the nurse training program for 17 years until serving in the Navy. White was in the first class (1908) of the Navy Nurse Corps. The group of nurses was called "The Sacred Twenty" because they were the first women to serve formally as members of the Navy. Being the charter class, the women needed to rent their own house and provide their own meals. They were assigned duty at the Naval Hospital in Washington, DC, and were met with much resentment from some of the men. White (back row, sixth from left) returned to St. Luke's Hospital from 1914 to 1919 as superintendent of the nursing program. (Courtesy of the Navy Bureau of Medicine and Surgery Library and Archives.)

Simon Rau

Rau (1818–1910) came to Bethlehem in 1825 and at the age of 12 became the apprentice to physician and pharmacist Dr. Everhard Freytag. He worked in what would become the longest-run pharmacy in America, founded by Dr. John Frederick Otto in 1745. The pharmacy was in continuous operation until 1954. The old building was demolished and a new pharmacy built on the site in 1862, retaining the original walls. Rau purchased the business in 1839. His son, Eugene A. Rau, took over the pharmacy in 1889. Rau was active in the Bethlehem community, serving several terms on the town council. He married Lucy Ann Luckenbach in 1842. (Courtesy of the Moravian Archives, Bethlehem.)

Joseph James Maura
Maura was an alderman and district justice for more than 36 years, beginning in 1956, for west Bethlehem. He was a technical assistant in the fabricated steel construction sales department of Bethlehem Steel Corporation for 24 years before retiring in 1970. Maura was a member of the Bethlehem Boys Club as a youngster, and continued his affiliation with the club until his death. Maura (1927–2004) was born in Bethlehem and married Isabel C. Fuoco in 1949. They had two sons. (Courtesy of the Bethlehem Area Library.)

John A. Gombosi
John "The Judge" Gombosi was born in 1921 in the same house he lives in today in South Bethlehem. He dropped out of Broughal High School in 11th grade to work in a slipcover factory and soon found a better job at Bethlehem Steel Corporation as a machine inspector. Beginning in 1954, he would serve 36 years as an alderman, justice of the peace, and district justice on the South Side. He never charged for weddings. In 1972, he received the Bethlehem Puerto Rican Beneficial Society certificate of recognition. (Courtesy of the Bethlehem Area Library.)

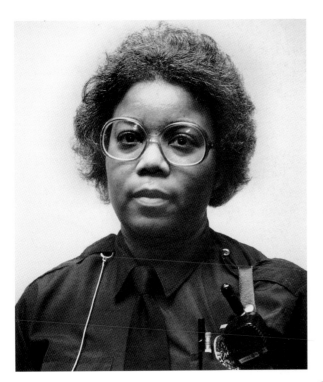

Vivian Williams Butts
In 1964, Vivian W. Butts was hired as the first female police officer in the Bethlehem Police Department. In 1980, Butts was promoted to sergeant and served in a supervisory post until her retirement in 1989. Butts was born in 1933 and graduated from Elizabeth City State University in North Carolina in 1956. She was married for 42 years to Raymond E. Butts, who passed away in 1999. They had a son and a daughter. (Courtesy of Bethlehem City Hall.)

Regino W. Cora
Cora was born in 1939 in Puerto Rico and grew up in New York City. He moved to Bethlehem in 1968 to be closer to family. His first job was as assistant manager of the Bethlehem Housing Authority (BHA). He left to become a police officer in 1970. Cora was appointed to the BHA board of commissioners, serving from 2001 to 2007. He became the first Hispanic Northampton County detective in 2002. A graduate of Lehigh Carbon Community College, Cora married Martha M. Merced, and they have five children. (Courtesy of the Bethlehem Housing Authority.)

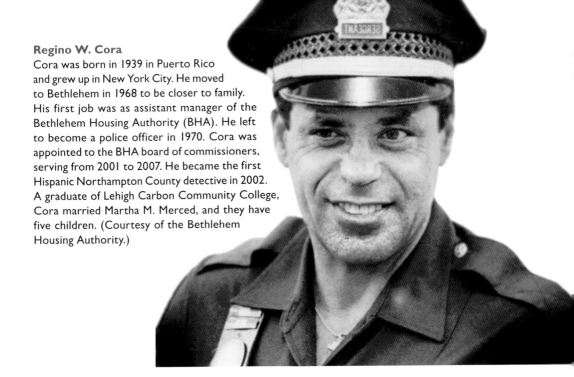

George J. Barkanic

Barkanic joined the Bethlehem Fire Department in 1981 and served as assistant chief beginning in 2000. Barkanic was named Bethlehem Fire Department commissioner in 2006, a fulfillment of his lifelong dream. He oversees 113 firefighters at five fire stations located throughout the city. Barkanic guided the equipping of fire trucks with defibrillators in 2006, as firefighters are often on the scene before ambulances can arrive. Barkanic was born in 1954 and graduated from Lehighton Area High School in 1972. He attended Lehigh University and earned an associate degree in fire technology from Northampton Community College in 1985. (Courtesy of the Bethlehem Fire Department.)

Augustus Belling

Belling (1808–1880) was born in Schoeneck, a small community north of Nazareth. He moved to Bethlehem at the age of 16 to become an apprentice to a shoemaker. Belling soon had his own shoemaking business on Broad Street. After 34 years of making shoes, Belling served as a toll keeper for 22 years on the old Lehigh Bridge. In 1832, Belling married Helen C. Borhek of Bethlehem, and the couple lived with their five daughters in the small brick toll keeper's house next to the bridge. The Belling family needed to be alert to the frequent flooding of the Lehigh River. Augustus Belling was very active in the Bethlehem community, serving as a member of the Bethlehem Band and as a constable. He was a founding member of the Bethlehem Library Association. (Courtesy of the Moravian Archives, Bethlehem.)

Joseph Weaver Adams

Adams (1877–1927) was born in the family mansion on West Third Street in Fountain Hill. He attended Moravian Parochial School, the Hill School of Pottstown, and Lehigh University. In 1892, Adams began his career working in the office of the Bethlehem Iron Company. The next year, he joined his father in a coal-mining business. Adams married Reba Thomas of Pittsburgh in 1899, and they had four children. He was very active in Bethlehem business and community affairs and was elected chief burgess of South Bethlehem, serving from 1911 to 1915. (Courtesy of the Moravian Archives, Bethlehem.)

Adam Brinker

Brinker (1846–1928) was born on a farm in Forks Township. In 1867, he opened a harness shop in Bethlehem. He made the first artificially produced ice in Bethlehem in 1898 through the Artificial Ice Company. Brinker served on the city council from 1878 to 1906. He married Lydia Sloyer, and they had two daughters. In 2007, when his last heir died, Brinker's trust fund of over $9 million went to three Bethlehem charities. He stipulated these charities as beneficiaries in his will. (Courtesy of the Moravian Archives, Bethlehem.)

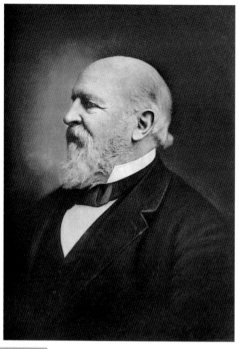

Charles Brodhead

Brodhead (1824–1904) was born in Conyngham, Pennsylvania, and was raised in Delaware, Pennsylvania. He graduated from Lafayette College in 1844 and joined the law office of his uncle. Although Brodhead was admitted to the bar, he found real estate more exciting. He was president of the Lehigh & Lackawanna Railroad in 1862. In 1873, Brodhead was elected a member of the constitutional convention of Pennsylvania. He married Camilla M. Shimer in 1858, and they had three children. (Courtesy of the Moravian Archives, Bethlehem.)

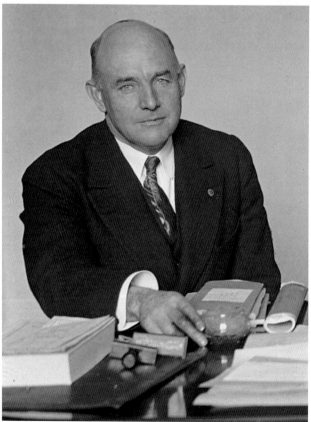

William Radford Coyle

Coyle (1878–1962) was born in Washington, DC. He joined the US Marine Corps, serving from 1900 to 1941. Coyle married Jane Weston Dodson in 1904, and they had two children. He attended the University of Pennsylvania Law School in 1907 and settled down in Bethlehem in 1908 to work at his wife's family business, Weston Dodson & Company, coal distributors. He eventually served as vice president of the company from 1932 to 1954. Coyle was elected representative of the 15th District and served from 1925 to 1933. (Courtesy of the Samuels Collection.)

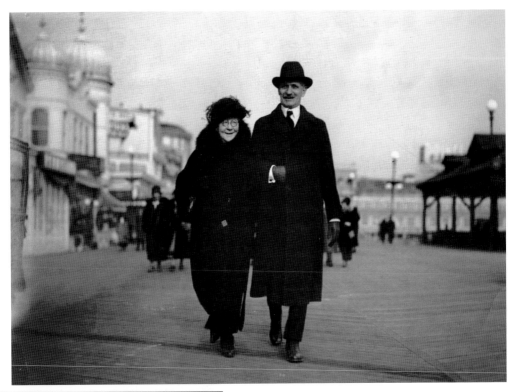

Almer Charles Huff

Huff (1869–1941) was born in Deibertsville, Pennsylvania, and attended school in Allentown. He learned the carriage-building trade when he was 16. Huff moved to Bethlehem in 1894 and opened a shop selling sewing machines. The next year, he added pianos to his inventory. By 1919, he had expanded his business, taking over an entire five-story building. Huff served six terms on West Bethlehem's council and was chief burgess in 1906. He married Annie Rosser in 1891, and they had one son. (Courtesy of Michael Kramer and Amey Senape.)

James E. Mathews Jr.

Mathews (1876–1935) was born on the family farm in Olney, Illinois, and attended Illinois State University. He graduated from the US Naval Academy at Annapolis and spent two years in the Navy. In 1901, Mathews was employed by the ordnance department of the Bethlehem Steel Company as an engineer, eventually becoming the manager. Mathews was elected a councilman of Bethlehem in 1918, and was the first president of the chamber of commerce. In 1905, he married Caroline Amelia Myers of Bethlehem, and they had three children. (Courtesy of the Moravian Archives, Bethlehem.)

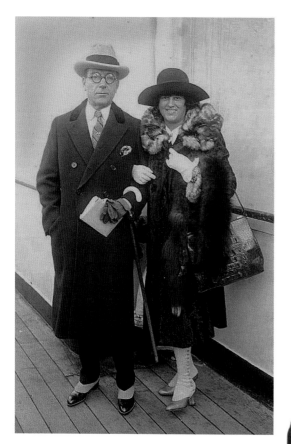

Dallett Hemphill Wilson and Esther Evans Wilson

Dallett Wilson (1879–1937) was born in Philadelphia and graduated from the University of Maryland Law School. In 1913, he opened a private practice in Bethlehem. He and Esther Evans De Forest of New York were married in 1910. After 18 years of marriage, the couple separated. On March 22, 1928, Esther visited Dallett in his office on Fifth Avenue and fired two gunshots at him. Wilson survived his injuries, and Esther Wilson was sentenced to serve time in the Women's Farm Colony at Greycourt, New York. (Courtesy of the Samuels Collection.)

Fred Bernard Rooney Jr.

Rooney was born in Bethlehem in 1925 and was a member of the Bethlehem Boys Club. He graduated from Bethlehem High School in 1944 and served in the US Army as a paratrooper from 1944 to 1946. He graduated from the University of Georgia at Athens in 1950 and served seven terms in the US House of Representatives and two terms in the state senate. A Bethlehem Housing Authority building was named for him. He and his wife, Evelyn "Evie" Davis Lisle, have two sons and a daughter. (Courtesy of the Samuels Collection.)

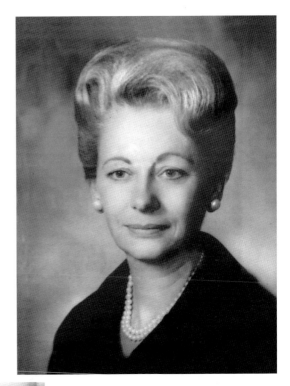

Elaine A. Meilicke
Meilicke (1921–2007) was born in Chicago. While attending St. Luke's Hospital School of Nursing in 1941, she married Dr. Francis Franklin Meilicke, chief of surgery at St. Luke's Hospital. After his death in 1970, she married Al E. Junker, who died in 1978. Meilicke married her third husband, Frank R. Barnako, an attorney for Bethlehem Steel Corporation, in 1999. Meilicke, a nursing instructor at Drexel University during World War II, was Bethlehem's first elected female council member, beginning in 1961, during the administration of Mayor Gordon Payrow. She was also a board member of several community organizations. (Courtesy of Bethlehem City Hall.)

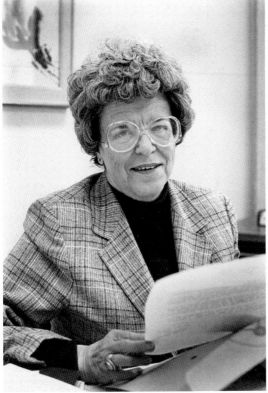

Dolores W. Caskey
Caskey was born in 1920 in New Mexico. She married James W. Caskey in 1947, and they had three sons. Caskey moved to Bethlehem with her husband in 1961 and worked as a columnist for the *Globe-Times* newspaper and served as a Spanish translator for Northampton County Court. Caskey was elected in 1973 to the Bethlehem City Council, serving for 11 years, including as the first female president in 1979 and 1982–1984. (Courtesy of Bethlehem City Hall.)

Jean Margaret Belinski
Belinski was born in Bethlehem in 1934, the daughter of Arthur and Marie Pursell. She attended Bethlehem Catholic High School (graduating in 1952) and Northampton Community College (graduating in 1982). She married Richard Anthony Boligitz in 1953, and they had three children. Richard died in 1976, and Jean married Walter Belinski in 1983. She was elected to the city council in 1998 and served four terms. In 1999, Belinski was inducted into Bethlehem Catholic High School's Distinguished Graduates hall of fame. (Courtesy of Bethlehem City Hall.)

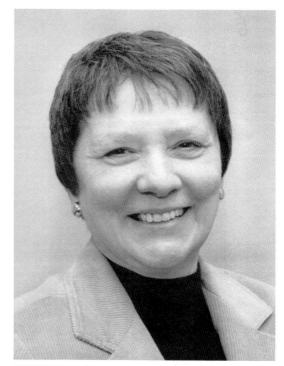

Lisa Boscola
Boscola was first elected to the Pennsylvania General Assembly in 1994. In 1998, she won a seat in the state senate and is currently chair of the consumer protection and professional licensure committee in the senate, as well as a member of the appropriations, judiciary, banking and insurance, game and fisheries, and rules committees. Boscola was born in 1962 in Bethlehem. She is a graduate of Freedom High School and received her bachelors and masters degrees from Villanova University. From 1987 to 1993, she was a Northampton County deputy court administrator. (Courtesy of Lisa Boscola.)

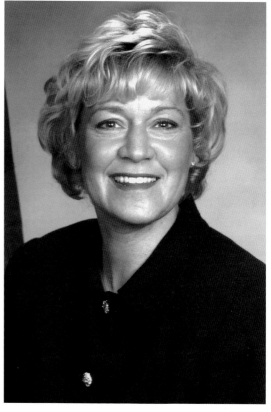

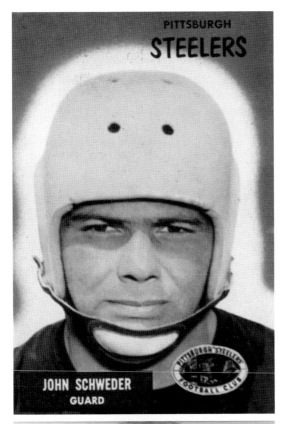

John "Bull" Schweder
Schweder (1927–2005), a native of Bethlehem, was noted for his large size. He was a football star for Liberty High School and the University of Pennsylvania and played offensive lineman for six seasons for the Baltimore Colts and Pittsburgh Steelers in the 1950s. He served in the Army during the Korean War. After leaving football, Schweder was a coach for Villanova University, Lafayette College, and the former Pottstown Firebirds of the ACFL. In 1999, the University of Pennsylvania named him to its first team all-century football team. In 1978, he was appointed the director of Bethlehem Parks and Recreation. (Courtesy of the Samuels Collection.)

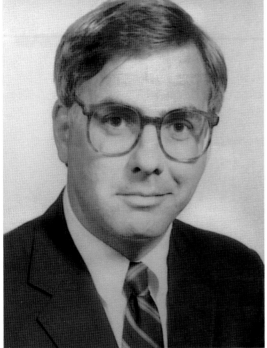

John Michael Schweder
Schweder, the son of John "Bull" Schweder and Mary Lyons, was born in 1949 in Bethlehem. He graduated from Liberty High School in 1967, Lycoming College in 1971, and the University of Michigan in 1988. Schweder was elected to the Pennsylvania House of Representatives at the age of 24, serving from 1974 to 1980. He was elected to Bethlehem City Council and served from 1998 to 2009. Schweder met his future wife, Annette Weaver, at Lycoming College. They have three children. Schweder became president of AT&T Mid-Atlantic Region. (Courtesy of Bethlehem City Hall.)

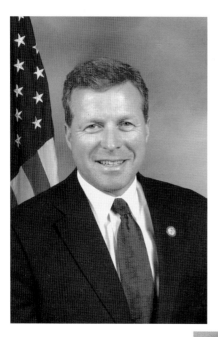

Charlie Dent
Dent was born in 1960 in Allentown to Marjorie and Walter R. "Pete" Dent. He graduated from William Allen High School in 1978, Pennsylvania State University in 1982, and Lehigh University in 1993. Dent was a member of the Pennsylvania state legislature for 14 years (1991–1998), and was elected to the US House of Representatives, serving from 2004 to 2014. He and his wife, Pamela, live in Allentown with their three children. (Courtesy of Charlie Dent.)

Louise de Schweinitz
Schweinitz (1897–1997) saw amazing changes in the medical care of infants. She was a pediatrician who graduated from Johns Hopkins Medical School in 1924. Schweinitz practiced medicine at Yale University, the Community Health Well Baby clinics, and the University of Kansas Medical Center. She was born in Nazareth, Pennsylvania. Her father, Paul de Schweinitz, a pastor of the Moravian Church, moved the family to Bethlehem in 1897. She met Daniel Cady Darrow when she was a second-year medical student at Johns Hopkins. They married in 1923 and had five children. (Courtesy of the Moravian Archives, Bethlehem.)

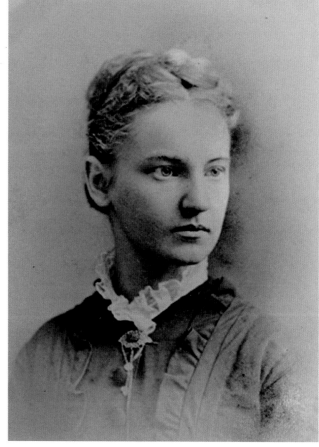

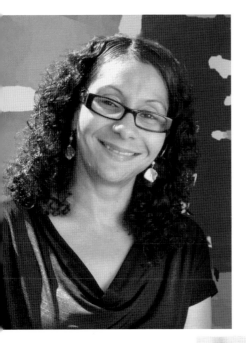

Lorna Velazquez
In 2011, Velazquez became the executive director at Hispanic Center Lehigh Valley. Prior to that, she was a family development specialist at the Calypso Elementary School in the Bethlehem School District. Velazquez oversees the Women, Infants and Children nutrition program and the Basilio Huertas Senior Center. She has worked toward using fresher food in the menu of the senior center. In 2012, Velazquez oversaw the opening of a new food pantry in South Bethlehem. She has successfully formed partnerships for the center with Lehigh University, Second Harvest, Bethlehem Health Bureau, the Community Action Committee of the Lehigh Valley, and Sands Casino Resorts, among several others. (Courtesy of Lorna Velazquez.)

Lupe Pearce
Pearce moved to the Lehigh Valley in 1970 and found the Hispanic community having great difficulty adjusting to their adopted country. In 1976, she started the Hispanic American Organization and in 1998, opened a center in South Bethlehem. Pearce was born in 1943 in Antofagasta, Chile. She married John Pearce while he was serving with the Peace Corps in Chile. The Pearces moved to the Lehigh Valley when John was offered a teaching position at Muhlenberg College. The couple, now separated, have three children. (Courtesy of Lupe Pearce.)

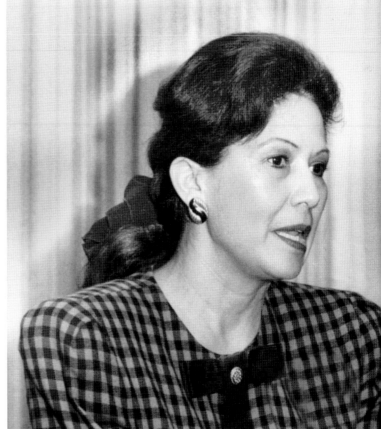

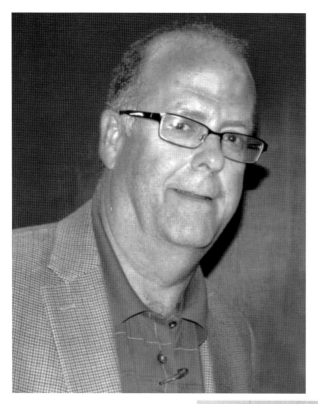

Alan L. Jennings

Jennings is the executive director of the Community Action Committee of the Lehigh Valley. He has been the driving force behind a range of programs designed to improve the quality of life for low-income people. Born in 1959 in Emmaus, Jennings graduated from Emmaus High School in 1976 and Dickinson College. Jennings married Denise Reynolds, and they have two daughters. In 1997, he opened the Community Action Development Corporation of Bethlehem, which offers classes in starting a business. Jennings reaches people through his talks, a radio show, and community partnerships. (Courtesy of Alan L. Jennings.)

Olga Negron

In 2011, Negron became the first executive director of the Levitt Pavilion SteelStacks, a nonprofit group that manages the new outdoor stage on the former Bethlehem Steel Corporation property. The venue offers 50 free concerts a year. In 2009, Negron was the director of the Council of Spanish Speaking Organizations of the Lehigh Valley. She was also a legislative assistant at the Pennsylvania House of Representatives. She has served on boards for Latino Leadership Alliance of the Lehigh Valley, Alliance for Building Communities, and the Community Action Development Corporation of Bethlehem. Born in Puerto Rico in 1943, Negron came to Bethlehem in 1997 after attending school in Florida and Texas. (Courtesy of the Samuels Collection.)

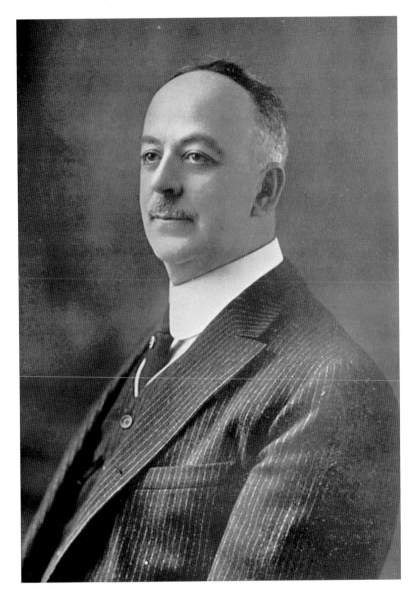

Archibald Johnston
Johnston (1865–1948) was the first mayor of the consolidated city of Bethlehem in 1918. He liked to drive the streets of Bethlehem and jot down the locations of potholes, to have them fixed later. He graduated from Lehigh University with a degree in mechanical engineering in 1889 and started work immediately at the Bethlehem Iron Company. Charles M. Schwab and Eugene Grace saw greatness in Johnston and made him vice president of Bethlehem Steel. No matter how difficult the project, he got it done in his usual efficient, calm manner and with a great regard for human dignity. When Johnston retired from Bethlehem Steel in 1927, it made headlines nationally. He was independently wealthy from his Bethlehem Steel stock. Johnston devoted his time to his large estate on Santee Mill Road. He put his mechanical ingenuity to work in keeping the Santee Grist Mill, built in 1722, in working order. Once a year, Johnston would ground grain at the mill for family and friends. He was born in Phoenixville, Pennsylvania, and moved with his family to Bethlehem when he was four years old. In 1891, he married Estelle Borhek, and they had two children. (Courtesy of the Moravian Archives, Bethlehem.)

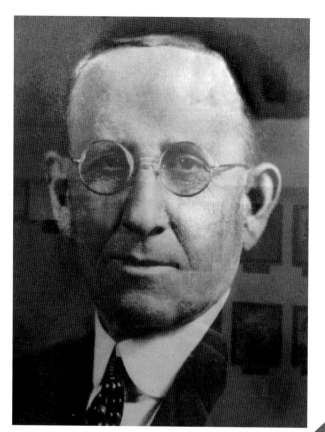

James Milton Yeakle
Yeakle (1860–1941) was born on the family farm near Bethlehem, and attended Bethlehem schools, including Moravian Parochial School. Yeakle worked on the farm until age 20, when he became an apprentice to a carriage builder. After 10 years of training, he opened up his own, very successful, carriage shop. Yeakle served as a councilman and, from 1914 to 1917, as a burgess of Bethlehem. During his two terms as mayor (1922–1930), the Hill to Hill Bridge opened in 1924. His inability to control crime on the South Side, however, cost him another term. (Courtesy of Bethlehem City Hall.)

Robert Pfeifle
Pfeifle (1880–1958) began his first term as mayor with a campaign to stop vice. He would go on to serve as mayor for 20 years (1930–1950). Pfeifle was born the second of eight children in Almont, Pennsylvania. At the age of 12, he began working full-time as a blacksmith. Looking for work, Pfeifle took the train to Bethlehem in 1902. He found work as a carpenter and found the love of his life, Gertrude E. Heller. They married in 1905 and had four children. Pfeifle established a contracting business and built more than 600 homes. (Courtesy of the Moravian Archives, Bethlehem.)

Earl E. Schaffer
As mayor from 1950 to 1962, Schaffer (1903–1982) identified the need for a new city hall complex and a strong-mayor government. As a supporter of urban renewal, he created the Redevelopment Authority. Schaffer demolished several blocks of old buildings with the plan to replace them with new ones. Schaffer, a native of Bethlehem, married Beatrice Cropper, and the couple had three children. Schaffer served as the Bethlehem Authority executive director from 1963 to 1972 and in 1975. The municipal ice rink was named for him in 2010. (Courtesy of Bethlehem City Hall.)

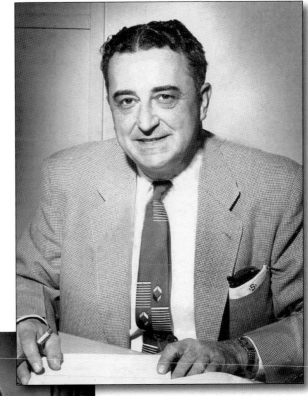

Gordon Payrow Jr.
Payrow (1918–2004) was the first mayor to serve under Bethlehem's strong-mayor form of government. During his terms in office (1962–1973) the construction of Route 378 began in 1966. The government had been run from seven different locations, but that changed when the new City Center opened in 1967. Payrow was born in Bethlehem and married Dorothy Parker in 1943. He was president of the Brown-Borhek lumber company in South Bethlehem and served as a city councilman from 1952 to 1956. Payrow Plaza at city hall was named for him in 2004. (Courtesy of Bethlehem City Hall.)

Gordon B. Mowrer
Mowrer was born in 1936 to Bethlehem dairy farmers. He graduated from Liberty High School in 1953, Dickinson College in 1959, Lehigh University in 1965, and Moravian Theological Seminary in 1989. Mowrer was president of Hampson Mowrer Kreitz Insurance for over 20 years, and served the Advent Moravian Church in Bethlehem as pastor from 1990 to 2002. Mowrer served as mayor from 1974 to 1977 and then as interim mayor in 1987. He was elected to city council and served from 2004 to 2010. He and his wife, Mary, have three children. (Courtesy of Bethlehem City Hall.)

Paul Marcincin
Marcincin was mayor from 1978 to 1987 after being a member of city council for 12 years. In 1985, Marcicin won a third term as mayor, in violation of the two-term limit ordinance. In 1997, he filled in for Ken Smith when Smith accepted a job as vice president for public affairs for Lehigh University. As mayor, Marcincin supported the idea of a Musikfest, which first took place in 1984. He oversaw the replacement of the Minsi Trail Bridge and the plan for a regional trash incinerator. (Courtesy of Bethlehem City Hall.)

Kenneth Smith

Smith took over the mayor's seat after a special election in 1987. He was elected mayor outright in 1988 and served until 1997. Smith governed the city as Bethlehem Steel Corporation ended its steelmaking operations, in 1995. He oversaw the city's 250th anniversary celebration. Smith accepted the post of vice president of public affairs with Lehigh University in 1997 and continued in that post until 2004. Smith, born in 1940 in Scranton, graduated from Lehigh University in 1961. He served in the US Navy as a lieutenant from 1962 to 1967. He and his wife, Barbara, have two children. (Courtesy of Bethlehem City Hall.)

Don Cunningham

Cunningham was born in Bethlehem in 1966 into a family of steelworkers. He was the first of his family to earn a college degree, graduating from Shippensburg University and Villanova University. Cunningham, his wife, Laura, and their three children reside in Bethlehem. He began his career as a local newspaper writer and was twice elected mayor of Bethlehem, serving from 1997 to 2005. Cunningham served as secretary of general services in the cabinet of Gov. Ed Rendell. In 2006, he became the first Democrat to win the position of Lehigh county executive. (Courtesy of Bethlehem City Hall.)

James A. Delgrosso
Delgrosso was appointed by the council to serve the remaining days of Donald Cunningham's mayoral term (2003–2004). Before becoming mayor, Delgrosso served as a member of Bethlehem City Council since 1982 and as president of the council from 1996 to 1997 and from 1990 to 1993. Delgrosso (1943–2009) was born in Bethlehem. He graduated from Kutztown University and Temple Universities and was a driver education teacher at Liberty High School from 1965 to 2003. He and his wife, Deborah, had two children. (Courtesy of Bethlehem City Hall.)

John B. Callahan
Callahan served on the Bethlehem City Council from 1998 to 2004; at the time of his election in 1998, he was the youngest councilman ever to be elected. Callahan serves on the board of directors of the Lehigh Valley Industrial Park, the Lehigh Valley Economic Development Corporation, and as the chair of the Urban Scouting Program in Bethlehem. Callahan grew up on the west side of Bethlehem and graduated from Moravian College. He and his wife, Mafalda, and their three children currently reside on the north side of Bethlehem. (Courtesy of Bethlehem City Hall.)

CHAPTER THREE

The Paragons of Originality

Bethlehem has always been small enough for each resident to feel a sense of belonging. When a child feels this security, they are often free to explore their own unique personal attributes and qualities. A good example of nurturing creativity and intellectual curiosity is the childhood of J. Fred Wolle, the founder of the Bach Choir. Wolle first learned to play the piano and melodeon (a small reed organ) when he was a toddler. As soon as his legs were long enough to reach the pedals of the organ in the Seminary Chapel, he taught himself to play it. During his years enrolled in the Moravian Day School, J. Fred played the organ for the morning services. He soon learned to play wind instruments and strings. J. Fred was called upon to play in the Trombone Choir on occasion and played viola for the church orchestra. He also began a lifelong study of spiders, a hobby he shared with his father.

The following description of Bethlehem from John Hill Martin's 1873 *Historical sketch of Bethlehem in Pennsylvania: with some account of the Moravian Church* describes a warm and spiritual place, isolated from a rapidly changing world:

> The first object that particularly attracts the eye, is the imposing school edifice, situated on the top of the hill. Near it looms up in the distance, the spire of the large Moravian church, and the belfry, from which the trombones sound the call to that joyous festival, the "Love Feast," or announce the death of one of the members of the brethren's church. Bounding from up high in the air, the sad, yet sweet dirges of the trombones, fill the hearer with a pleasing melancholy. It is one of these outward religious ceremonies which the Moravians still observe. May it long be cherished, and ever remain as a mark of their gentle faith, far too many of the forms and time-honored customs of the Church, have been abandoned, by the town and people becoming Americanized.

Jedidiah Weiss
Weiss (1796–1873), a native of Bethlehem, was apprenticed to a silversmith and watchmaker at the age of 16. He proved to be exceptionally talented and took over the business at age 19. Weiss improved and maintained the clock on the cupola of the Central Moravian Church. He was a singer and a renowned bass trombone player, performing in the trombone quartet for 50 years. In 1820, he married Mary Stables of Alexandria, Virginia, who was a teacher in the Young Ladies' Seminary. The couple had four children. (Courtesy of the Moravian Archives, Bethlehem.)

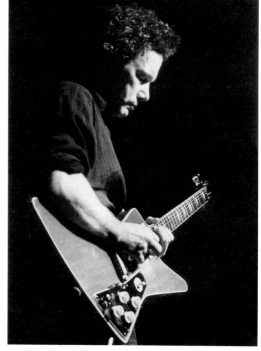

Steve Kimock
Kimock, born in Bethlehem in 1955, was influenced by his folksinger aunt, Dorothy Siftar. After playing in a series of high school bands and with the Goodman Brothers, Kimock joined the Heart of Gold Band with Grateful Dead members Keith and Donna Godchaux and drummer Greg Anton. In 1984, Kimock and Anton cofounded Zero, an instrumental psychedelic jazz/rock/blues band that would define his fluid style of melodious improvisation. Kimock, nicknamed "The Guitar Monk" by *Relix* magazine, inspired Jerry Garcia to say he was his favorite unknown guitarist. (Courtesy of Steve Kimock.)

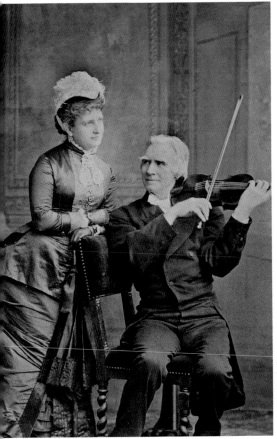

Emma Thursby with Violinist Bull Ole
In 1857, 12-year-old Emma Thursby (1845–1931) was enrolled in the Moravian Seminary in Bethlehem. Her parents selected the school for its excellent academic curriculum and, most important, for the outstanding musical training program. By the 1880s, Emma was the most famous concert singer in the world. Although she had met the royalty of Europe, a concert in 1885 brought her the greatest pleasure. Emma returned to Bethlehem to sing at the Moravian Central Church and was accompanied on the organ by Fred Wolle, the son of her childhood teacher, Francis Wolle. (Courtesy of the Samuels Collection.)

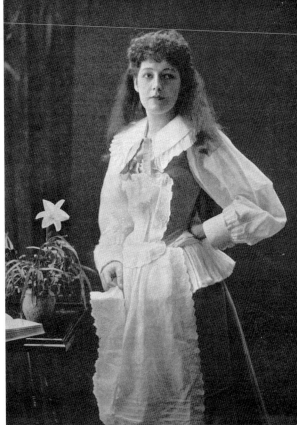

Mary Augusta Yohe
Yohe (1866–1938) was born in the Eagle Hotel, where her grandfather, Caleb Yohe, was the proprietor and where the family lived. When Yohe was 12, her mother sent her to Europe to be educated. She returned to the States three years later and began her career on the stage. Yohe became a stage star who married into British royalty and whose love life was documented in newspapers on two continents. She married Lord Francis Hope, the Duke of Newcastle, in 1894. He was the owner of the 45.52-carat, deep-blue Hope Diamond. Yohe retired from the stage in 1921, finding that her performances were in less demand. (Courtesy of the Samuels Collection.)

John Valentine Haidt
Haidt (1700–1780) was one of America's earliest great painters. He is known for his dramatic depictions of Biblical ideas and his later portraits of Moravian church members and the early leaders of Bethlehem. Haidt was born in Danzig, Germany, and learned the craft of goldsmithing from his father. After joining the Moravians in 1740, he dedicated his life to preaching and painting religious subjects. The work shown here is a self-portrait. Haidt and his wife, Catherina Kompigni, arrived in Bethlehem in 1754. (Courtesy of the Moravian Archives, Bethlehem.)

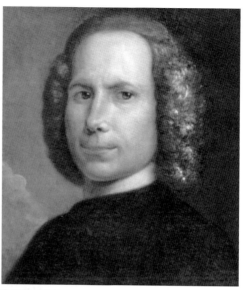

DeWitt Clinton Boutelle
Boutelle (1820–1884) settled in Bethlehem at the age of 38. He established a studio and home with his wife, Frances, and three children. Boutelle painted stunning scenery in New York, New Jersey, and Pennsylvania. He was elected a member of the Pennsylvania Academy of the Fine Arts and the National Academy. Boutelle was commissioned by a group of Asa Packer's associates in 1873 to produce a life-sized painting of Packer, pictured here. The painting was presented by Packer's sons to Lehigh University on the first Founder's Day, October 9, 1879. (Courtesy of the Moravian Archives, Bethlehem.)

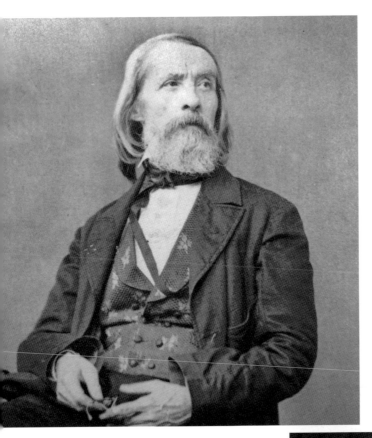

Gustavus Grunewald
Grunewald (1805–1878) was born in a Moravian settlement in Gnadau, in East Prussia. He studied painting at the Dresden Art Academy and with Gottfried Wilhelm Volcker, a still-life painter. In 1831, Grunewald married Maria Justina Lehman, a teacher. The couple arrived in Bethlehem in 1831, and Grunewald was soon appointed drawing master at the Moravian Seminary for Young Ladies. After his wife's death in 1865, Grunewald returned to Germany and married Mathilde Josephine Rieger. (Courtesy of the Moravian Archives, Bethlehem.)

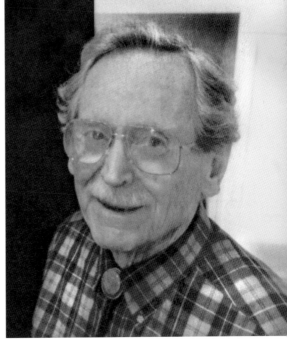

Fred T. Bees
Bees (1917–2002), a native of Bethlehem, was a watercolorist, teacher, and the winner of numerous painting awards. Even without a formal art education, he taught the medium for 33 years. In 1996, he was named Artist of the Year by the Bethlehem Fine Arts Commission. He worked for Bethlehem Steel Corporation for 35 years before retiring as a quality control supervisor in 1976. He and his first wife, Johanna Faust, had three children. He married Mary (Musselman) Herber in 1980. (Courtesy of the Samuels Collection.)

Charles Frederick Beckel
Beckel (1801–1880) opened an iron foundry
and machine shop in Pennsylvania in 1825 to
utilize the newly built Lehigh Canal. He played
alto trombone for the famous Trombone
Quartette of the Moravian Church for over
50 years. Beckel was born in Bethlehem
and, at the age of 12, was apprenticed to a
watchmaker. In 1823, he married Charlotte
Frederica Brown, a music teacher. They were
married for 57 years and had four children
together. Beckel was a member of the town
council (1854–1857) and served as town
burgess (1864–1870). (Courtesy of the
Moravian Archives, Bethlehem.)

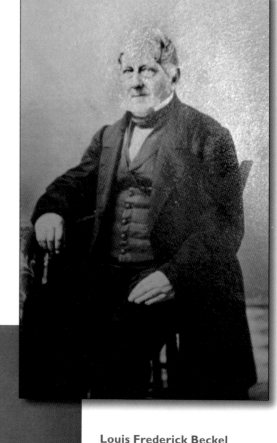

Louis Frederick Beckel
Louis, the son of Charles F. and
Charlotte Beckel, was born in
Bethlehem. He worked in the
Moravian Congregation store and
eventually started his own shoe
store in South Bethlehem. He
married Caroline R. Eberman in
1848, and they had five children.
Beckel served as chief burgess
(1866–1868) and councilman
(1865–1866). He was appointed
postmaster of South Bethlehem in
1866. Beckel (1826–1881) was the
originator of the first brass band
of Bethlehem. He was a member
of the Philharmonic Society and
the Moravian trombone choir.
(Courtesy of the Moravian
Archives, Bethlehem.)

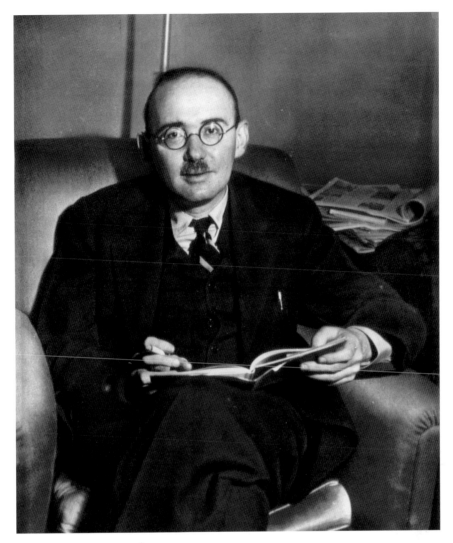

Stephen Vincent Benèt
Benèt (1898–1943) was born in Fountain Hill, Pennsylvania, to Col. J. Walker Benèt and Frances Neill (Rose) Benèt. Colonel Benèt brought his family to the house on the corner of Ostrum and Bishopthorpe Streets while serving in the Army. He was an inspector of the arsenal produced by Bethlehem Iron Company in South Bethlehem, from 1894 to 1898. Soon after Stephen was born, the Army moved Colonel Benèt and his family to New York, then to Illinois and California. As a child, Benèt suffered from a case of scarlet fever, which left him with impaired eyesight. He was schooled at home during his primary years, then attended the Hitchcock Military Academy and The Albany Academy for his secondary school education. Before he attended Yale University, he was already an accomplished poet. He published his first poem at age 16 in *The New Republic* magazine and, at age 17, published his first book of poetry, *Five Men and Pompey* (1915), then *The Drug-Shop* (1917). Benèt received the Guggenheim Fellowship in 1926, which allowed him to write *John Brown's Body*, a 15,000-line epic about the Civil War, for which he received the Pulitzer Prize in 1929. Benèt met his wife, Rosemary Carr, the writer and journalist, in 1920 as he was studying at the Sorbonne in Paris. They married in 1921 and had a son and two daughters. Benèt died of a heart attack in 1943 at the age of 44. He was awarded a posthumous Pulitzer Prize in 1944 for *Western Star*, an unfinished narrative poem on the settling of America. (Courtesy of the Samuels Collection.)

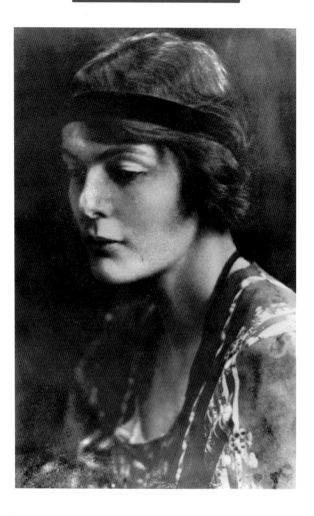

Hilda Doolittle

Doolittle (1886–1961), known as the poet H.D., was born in her parents' house in Bethlehem. She was educated at the Moravian Girls' Seminary and the Friends' Central School in Philadelphia. She was tall (five feet, eleven inches) and enjoyed playing basketball. In 1905, Doolittle entered Bryn Mawr College but withdrew after three semesters due to failing calculus and English. In 1901, Ezra Pound attended a Halloween party at the Burd School in Philadelphia and met Doolittle, then 15. They continued their friendship, leading to an engagement in 1908. They never married, but remained friends for the rest of their lives. Through Pound's influence, Doolittle grew interested in and quickly became a leader of the Imagist movement in poetry. In 1911, she traveled to Europe and, except for a few brief visits, never again lived in the United States. Doolittle, who described her sexual orientation as bisexual, was married to the British poet Richard Aldington from 1913 to 1938. She had a daughter in 1919 with the painter Cecil Grey. In 1918, Doolittle met British writer Bryher (Annie Winifred Ellerman), who became her lover for the rest of her life. In 1933, she traveled to Vienna to undergo analysis with Sigmund Freud to overcome writer's block and to better understand her relationships. Doolittle wrote three novels and several collections of poetry, including *Trilogy* (1942), *Sea Garden* (1916), *Helen in Egypt* (1961), and *Collected Poems, 1912–1944* (1983). She was awarded the Harriet Monroe Prize (1956) and the Gold Medal Award from the American Academy of Arts and Letters (1960). She appeared in the film *Borderline* (1930), in the role of Astrid. Her ashes are buried at her grave in Bethlehem. Over the years, admirers have placed flowers and seashells on her gravestone. The seashells honor Doolittle's frequent use of the image of the seashell in her poetry. (Courtesy of the Samuels Collection.)

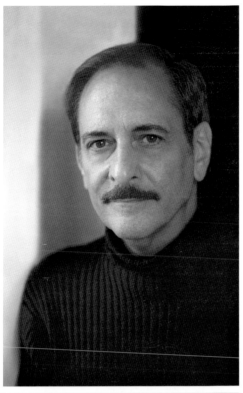

Kenneth F. Raniere
Raniere was born in Italian East Harlem, in New York City, in 1946. At the age of 22, he moved with his family to Bethlehem. After graduating from Kutztown University, he taught art from 1972 to 1979. Raniere became graphics editor for the *Morning Call* in 1981, winning numerous awards. He recently wrote *A Living Legacy: Architecture of A. W. Leh* (2009), for which he received an Independent Publisher (IPPY) Bronze award, and the Arts Ovation award from the Allentown Arts Commission, both in 2010. (Courtesy of Kenneth F. Raniere.)

Graham P. Stanford and Bo
Stanford, born and raised in Bethlehem, graduated from Lehigh University in 1999. After living in Argentina, Spain, Ireland, and Des Moines, he returned to Bethlehem as a restoration carpenter/contractor. In 2003, he founded the nonprofit, all-volunteer SouthSide Film Festival, serving as director until 2012. In the nine years of his tenure, 778 independent films were screened from 41 states and 80 countries, and the festival hosted 181 filmmakers. The goal was to offer and sustain a noncommercial, artist-focused, community-oriented festival operating, annually, in the black. (Courtesy of Graham P. Stanford.)

C.A.P. Turner

Turner (1869–1955) was born in Lime Rock, Rhode Island, and graduated from Lehigh University in 1890. He earned fame with his design of a ferry bridge in Duluth, Minnesota, built in 1904. Also in 1904, in Minneapolis, Turner designed the first building to use reinforced concrete columns and floors. In this photograph, he is standing third from the left at Minneapolis Test Load. He wrote articles and books about his inventive designs. In 1936, Turner, with his wife, Mary, moved to Columbus, Ohio, where he owned the George H. Wegener Company, a condiments manufacturer. (Courtesy of Meghan Elliott, Ryan Salmon.)

Albert Wolfinger Leh

Born on the family farm in Williams Township, Pennsylvania, Leh was nicknamed "Captain" for his service as a corporal in the Infantry Regiment of Pennsylvania. When Leh (1848–1918) returned from the Civil War, he enrolled in a business course. He soon discovered his love of architecture and opened an office, in 1883. Leh's designs shaped the street scene in Bethlehem more than any other architect. In 1884, Leh married Alice Ruton of Philadelphia. After Alice's death in 1900, Albert married her sister, Hulda Ruton. (Courtesy of Moravian Archives.)

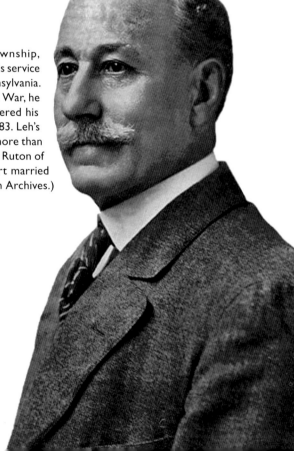

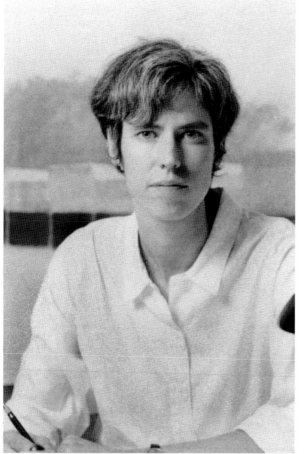

Christine Ussler
Ussler is an architect, preservationist, and professor. She founded her firm, Artefact Inc., in 1986. Ussler has been the historic officer consultant for Bethlehem since 1988. She has designed theaters, museums, restaurants, educational facilities, residences, and recreation facilities. Artefact was awarded the 2012 AIA Eastern Pennsylvania Award of Merit for Private Residence in Northampton County. Ussler has been a professor of practice for Lehigh University since 1984. She graduated summa cum laude from Lehigh University in 1981 and from Columbia University in 1984. Ussler is married to John Trumbull. (Courtesy of Christine Ussler.)

Otto Henry Spillman
Spillman (1895–1979) was born in Wilkes-Barre, Pennsylvania, and moved with his family to Bethlehem as a young boy. He attended Lehigh University, graduating in 1920. His first job was as a draftsman for Bethlehem Steel Ship Building Corporation. Spillman set up a practice in Bethlehem in 1927 with partner Curtis M. Lovelace. They began their career designing homes for Bethlehem Steel executives. The firm, known today as Spillman Farmer Architects, conceived iconic buildings in Bethlehem. He married Ruth Miller and they had three children. (Courtesy of the Samuels Collection.)

Gustav Adolph Conradi
Conradi (1867–1933) was born in Bethlehem and attended Moravian Parochial School. As a young man, he was an apprentice barber under his father. However, he soon pursued his favorite hobby, photography, and set up his own studio on Broad Street. In the 40 years that Gustav was a photographer, he documented all aspects of life in Bethlehem. Conradi married Emma M. Kuntz in 1892. He died at age 65 from a heart condition. (Courtesy of the Moravian Archives, Bethlehem.)

Carol Guzy
Guzy, who grew up in Bethlehem, is a four-time winner of the Pulitzer Prize in photography and has covered political uprisings, earthquakes, volcano eruptions, genocide, and civil war. Initially, Guzy planned to become a nurse, but instead became a photographer. She married United Press International photographer Jonathan Utz in 1988. In 1990, Guzy was the first woman to receive the Newspaper Photographer of the Year Award, presented by the National Press Photographers Association. She was given the award two more times. The dog in this photograph was a rescue from Hurricane Katrina. (Courtesy of Felicia Gruver.)

Gelsey Kirkland and Mikhail Baryshnikov
Kirkland was born in Bethlehem in 1952. She received her early training at the School of American Ballet. At age 15, she joined the New York City Ballet, and in 1974, she joined the American Ballet Theatre as partner to Mikhail Baryshnikov. Kirkland received worldwide acclaim for her performances in the classical repertory. She has cowritten three books, and First Lady Nancy Reagan honored her at the White House. Retirement from the stage in 1986 marked Kirkland's transition into teaching. (Courtesy of Gelsey Kirkland.)

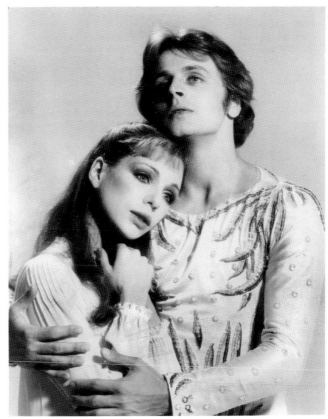

Marjorie B. Fink
Known as "the First Lady of Dance," Fink (1900–1989) taught dance for 50 years. She was the founder of the Ballet Guild of the Lehigh Valley and operated her school and the guild from her Main Street location until retiring in 1973. Fink, born in Bethlehem, married Russell Fleming, with whom she had a son. In 1982, the Bethlehem Housing Authority dedicated a community building to her in recognition of her work as a playground supervisor at Pembroke Village for 22 summers. (Courtesy of the Bethlehem Housing Association.)

Bill White

White has been a writer for the *Morning Call* in Allentown, Pennsylvania, since 1974. Also, for the past 20 years, White has conducted yearly tours of spectacular displays of Christmas lights. Through the tours, hundreds of dollars are donated each year to the Second Harvest Food Bank. He is a graduate of Lehigh University and Ohio State University (1981) and has been teaching journalism as an adjunct at Lehigh for 25 years. White and his wife, Jane, an editor at the *Morning Call*, have two children. (Courtesy of Bill White.)

Frank J. Mikisits

Mikisits (1918–1999) was born in Northampton, Pennsylvania, and maintained strong ties with his family's village in Szentpetertz, Hungary. Mikitsits was an Army veteran of World War II and a burner at Bethlehem Steel Corporation for 40 years until retiring in 1980. Mikisits preserved the old Hungarian songs on his *Hungarian Hour* radio show for more than 40 years. A Bethlehem resident for many years, Mikisits married Helen Kosak, and they had two children. Helen passed away in 1990. He married Theresa Lucky in 1991 and gained a stepdaughter. (Courtesy of the Samuels Collection.)

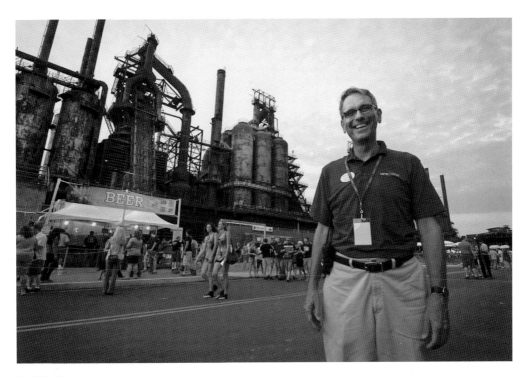

Jeff Parks

Parks, born in Bethlehem in 1948, graduated from Liberty High School, Lehigh University in 1970, and the University of Pennsylvania Law School in 1973. He and his wife, Susan, raised their children in Bethlehem. In 1984, Parks thought of the innovative idea of Musikfest, which would bring in much-needed revenue to the city of Bethlehem. He had confidence that the festival could attract at least 100,000 visitors to the city. The Musikfest organization eventually evolved into ArtsQuest, which facilitated Christkindlmarkt (1991), the Banana Factory Community Art Center (1998), and SteelStacks (2011). (Courtesy of Frank T. Smith.)

Greg Funfgeld

Funfgeld was born in 1954 in Long Island, New York, and graduated from Westminster Choir College in New Jersey in 1976. He has been artistic director and conductor of The Bach Choir of Bethlehem and The Bach Festival Orchestra since 1983. Under his leadership, The choir's 100 members have achieved a level of musical excellence that has been recognized internationally. In 2007, he was awarded an honorary doctorate of humane letters from Lehigh University in recognition of his musical accomplishments locally, nationally, and internationally. (Courtesy of Bethlehem Bach Choir.)

Jimmy DeGrasso

DeGrasso was born in Bethlehem in 1963 and graduated from Liberty High School, where he received accolades for his drumming in the band, orchestra, and jazz band. Soon after graduation in 1981, DeGrasso took a chance and went to Los Angeles to find work as a drummer, and he has never stopped. He has performed, toured, or recorded with Ozzy Osbourne, Lita Ford, Y&T, Megadeth, David Lee Roth, and Alice Cooper. With Alice Cooper, he appeared in the movie *Wayne's World*. Pearl Drums introduced a signature snare drum, and Sabian, the 23-inch OverRide Cymbal, for DeGrasso. (Courtesy of Jimmy DeGrasso.)

Thom Schuyler

Schuyler was born in Bethlehem in 1952 and graduated from Liberty High School in 1970. He attended Drexel University in Philadelphia. Schuyler moved to Nashville in 1978, and his songs began to get noticed. Schuyler wrote songs recorded by more than 200 artists, including "16th Avenue" for Lacy J. Dalton, "Love Will Turn You Around" for Kenny Rogers, and "I Don't Know Where to Start" for Eddie Rabbitt. In 2011, he was inducted into the Nashville Songwriters Hall of Fame. Schuyler and his wife, Sarah, are raising their three children in Nashville. (Courtesy of Thom Schuyler.)

Ramona LaBarre
LaBarre was raised in Irving, Texas, where her father's country-and-western singing influenced her passion for music. Today, she is the managing director of Godfrey Daniels. Her involvement with the venue led to work with the Celtic Cultural Alliance and Celtic Classic, the Northeast Region of Folk Alliance, the selection committee for the Landhaven concert series in Huffs Church, and the Lehigh Valley Storytelling Guild. LaBarre has two grown children and now lives in Berks County with her fiancé, musician Jack Murray. (Courtesy of Ramona LaBarre.)

Dave Fry
Fry, raised in Upstate New York, graduated from Lehigh University in 1973. In 1976, he founded Godfrey Daniels, a 100-seat listening club that remains an important Bethlehem music venue. Fry loves teaching children about music, and his *I Like Peanut Butter* CD won Best Re-release from the Children's Music Web in 1999. Fry developed the educational program *RockRoots*, which won a Best Children's Programming award in 1991. He continues to perform family music at festivals, including Musikfest, the Philadelphia Folk Festival, and the New Jersey Folk Festival. (Courtesy of Dave Fry.)

Daniel James Roebuck

Roebuck is an actor, writer, and director. He appeared in the movies *The Fugitive*, *US Marshals*, *Halloween*, and *Final Destination*, and in television on *Matlock*, *Lost*, and *The Walking Dead*. The critics applauded his haunting portrayal as the killer Samson in *The River's Edge*. Roebuck was born in 1964 and graduated from Bethlehem Catholic High School. He says that he has fulfilled nearly every dream of his childhood, such as appearing in *Mad* magazine and becoming a toy and a Halloween mask. He lives in Southern California with his wife and two children. (Courtesy of Daniel J. Roebuck.)

Jonathan Scott Frakes

Frakes was born in 1952 in Bellefonte, Pennsylvania, and grew up in Bethlehem. He graduated from Liberty High School in 1970, where he ran track and played with the Grenadier Band. Frakes graduated from Penn State University in 1974. The role that would bring Frakes worldwide fame was that of Commander William Riker on *Star Trek: The Next Generation* (1987–1994). Frakes married actress Genie Francis in 1988. They live in California with their two children. (Courtesy of Jonathan S. Frakes.)

Dwayne Johnson
Johnson was born in 1972 in California. He moved with his family to Bethlehem when he was 17. He attended Freedom High School and played several sports. Johnson played defensive tackle for the University of Miami. Like his father and grandfather, Johnson trained to be a professional wrestler and made his WWF debut as Rocky Maivia in 1996. Johnson won nine World Heavyweight Championships, and his wrestling career led to his first leading movie role, in *The Scorpion King* (2002). Johnson and his ex-wife, Dany Garcia, raise their daughter in California. (Courtesy of Dwayne Johnson.)

Lynn Olanoff
Olanoff has covered the city of Bethlehem for the *Express-Times* since July 2008. Olanoff, a resident of Bethlehem's East Hills neighborhood, covers city government, the redevelopment of the Bethlehem Steel site, and other local stories for the newspaper. The community has appreciated her well-researched articles and her willingness to ask tough questions. (Courtesy of Lynn Olanoff.)

Mario Gabriele Andretti

Andretti was born in 1940 in Motovun, Croatia. The Andretti family immigrated to the United States in 1955, settling in Nazareth, Pennsylvania. Mario was racing cars before the age of 13. He went on to be named US Driver of the Year in three decades (1967, 1978, and 1984) and became the first driver to win IndyCar races in four different decades. In 2006, Andretti was awarded the highest civilian honor given by the Italian government, the Commendatore. Andretti and his wife, Dee Ann, still live near Nazareth, where they raised their family. (Courtesy of Mario Andretti.)

Edward (Eddie) Julius Sachs Jr.

Sachs (1927–1964) was born in Allentown, Pennsylvania. At age 20, he met driver "Dutch" Culp of Allentown, who influenced him to become a racer. In 1957, Sachs passed his Indianapolis rookie test and set speed records. He became an international star for his driving skills and gregarious personality, earning the nickname "the clown prince of racing." Sachs married Nancy McGarrity of Coopersburg, Pennsylvania, in 1959, and they had a son. On May 30, 1964, Sachs and Dave McDonald were killed on the second lap of the Indianapolis 500 race. (Courtesy of the Samuels Collection.)

Allen Woodring

In 1920, Woodring (1898–1982) of South Bethlehem won a gold medal in the 200-meter race at the Olympics in Antwerp, Belgium. Woodring was born in Hellertown, Pennsylvania, in 1898, and moved as a young child with his parents to South Bethlehem. He attended Syracuse University, graduating in 1923, where he ran for track coach Tom Keane, who saw in him an Olympic champion. In 1923, Woodring worked for the Spalding Sporting Goods Company as a salesman. Woodring married May Louise Reynolds, a teacher. (Courtesy of the Samuels Collection.)

William Sheridan

When Sheridan retired in 1952 as the Lehigh University wrestling coach, he was considered the greatest wrestling coach in the history of the sport. Lehigh University hired Sheridan two years after he had emigrated from Scotland in 1908. He was born in 1885 near Loch Lomond, and at age 17, Sheridan won the British Isles Featherweight Wrestling Championship. Sheridan lived in Bethlehem with his wife, Emily, and four children. He was the manager of the Bethlehem Steel Club soccer team, which won the 1917–1918 national championship. (Courtesy of Lehigh University.)

Willie Loughlin

Loughlin (1898–1967) grew to be a fearless street battler in South Bethlehem. When he was 25, one of his friends suggested he take up fighting in the ring, and in a span of 10 years, he became the uncrowned welterweight boxing champion. He had his first professional fight in 1914 in Bethlehem against the Irish-born Martin Canole. Loughlin knocked out Canole in the third round. He became known as "KO Willie Loughlin" for knocking out 11 fighters in a row. He fought Jack Britton, Ted Lewis, George Chip, Mike O'Dowd, and Jimmy Slattery, top boxers at the time. Loughlin decided to end his career in 1929 due to poor eyesight. (Courtesy of the Samuels Collection.)

Frederick "Fritz" Mercur

Mercur (1903–1961) was born in Williamsport, Pennsylvania. After his father died, his mother married an Italian count. The family moved to Florence, Italy, and Mercur was educated in Italy, Switzerland, and France. He graduated from Lehigh University (1927) and decided to make Bethlehem his home. He settled down with his wife, Elizabeth "Betsy" Pape, and raised a daughter. Mercur was a nationally known tennis player in the 1920s, and was a tennis coach at Lehigh University from 1935 to 1948. He also sold life insurance. Mercur is pictured on the left, shaking hands with Johnny Doeg. (Courtesy of the Samuels Collection.)

John Spagnola

Spagnola was born in Bethlehem in 1957 and attended Bethlehem Catholic High School, graduating in 1975. At Yale University, he was the leading receiver. In the NFL, Spagnola played 11 seasons (1979–1987) for the Philadelphia Eagles. He played for the Seattle Seahawks in 1988 and for the Green Bay Packers in 1989, and played in Super Bowl XV. He was a broadcaster for ABC Sports television from 1992 to 1998. Today, he is the managing director of Public Financial Management Group. Spagnola resides in Bryn Mawr, Pennsylvania, with his wife, Kathleen, and their three daughters. (Courtesy of the Walt Disney Company, ABC Sports.)

Charles "Chuck" Philip Bednarik

Bednarik was born in 1925 and grew up in South Bethlehem. He began playing football at Liberty High School, graduating in 1943. In his senior year, he entered the US Army Air Force and flew on 30 combat missions. He excelled in football at the University of Pennsylvania, which led to a professional football career with the Philadelphia Eagles (1949–1962). Bednarik was inducted into the Pro Football Hall of Fame in 1967. Today, Bedarik lives in Coopersburg with his wife, Emma Margetich. (Courtesy of the Samuels Collection.)

Billy Packer
Packer was born in 1940 in Wellsville, New York. He moved with his family to South Bethlehem in 1948 when his father became the Lehigh University basketball coach. Packer attended Liberty High School and was a guard for the Wake Forrest basketball team in Winston-Salem, North Carolina. For three decades, starting in 1972, he was a color analyst for television coverage of college basketball. Packer won a Sports Emmy Award in 1993 and has written several books. Packer and his wife, Barbara, reside in Charlotte, North Carolina, and raised three children. (Courtesy of CBS Broadcasting Inc.)

Pete Carril
Carril, the son of a steelworker, was born in 1930 and grew up in Bethlehem. He is a graduate of Liberty High School, where he played basketball. During his years as the Princeton University basketball coach (1967–1996), Carril compiled a 514-261 record, the best of any coach in Ivy League basketball history. He was inducted into both the National Collegiate Basketball Hall of Fame and the Naismith Basketball Hall of Fame in 1997. He married Dolores L. Halteman, and they have two children. (Courtesy of Princeton University.)

CHAPTER FOUR

The Advocates of Compassion

You can find compassion in Bethlehem throughout its history. The Moravian diaries that document the first 100 years of life in Bethlehem show many examples of compassion, including concern for the mentally ill, sympathy for a couple's disagreements, and understanding for a loss of faith. Walking through God's Acre, the Moravian Church cemetery along Market Street, one finds proof of the essential qualities of a compassionate community. Even in death, members were treated with respect and equality. Each gravestone is of the same proportions—small, flat tablets laid flush with the earth. No one person stands out among the stones. The cemetery contains the graves of European immigrants, African American slaves, and Native Americans. Created in 1742, it is the oldest perpetually maintained cemetery in the country and continues to be a peaceful place to visit. In the darkest part of the Great Depression, the mayor showed great compassion. Robert Pfeifle pulled together a committee to create a boys club in 1931. The Bethlehem Boys Club opened at 327 Broadway, in a former Moose Home. Edwin Van Billiard described the first day of operation as challenging when 1,300 boys showed up. The Boys Club of America added Girls to their name in 1988. Mayors, judges, councilmen, businessmen, and professional football players were once members of the Bethlehem Boys Club. Some of the local men who have volunteered long hours to the club are Tom Foley, Joseph Hassick, Peter DeAngelis, Al Saemmer, Stephen Dolak, Glen Walters, Al Tulio, Alan Dillman, John Betts, Michael C. Schrader, James Borso, Vincent Brugger, Pat Connell, Michael Lazun, and Pat Pazzetti III. Two Bethlehem clubs continue to operate today, providing safe places to have fun for boys and girls between the ages of 6 and 18. In the early 1980s, residents were suffering through a recession. The Episcopal Diocese of Bethlehem created the New Bethany's Transitional Housing Ministry, a shelter located at Fourth and Wyandotte Streets. Today, New Bethany Ministries provides meals, shelter, and life-skill classes to the homeless. If there is a need, the people of Bethlehem will offer comfort.

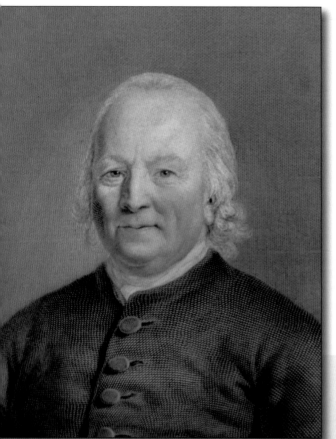

Augustus Gottleib Spangenberg
Spangenberg (1704–1792), the son of a Lutheran pastor, was born in Klettenberg, Germany. He studied theology at the University of Jena, graduating in 1726. In 1733, he joined the Moravian community at Herrnhut, and in 1744, he was consecrated as a Moravian bishop for North America. Spangenberg led a small group of Moravian settlers to their initial settlement in Savannah, Georgia, in 1735 and then to Bethlehem, Pennsylvania, in 1741. He was an eloquent preacher and a talented administrator. He returned to Germany after Zinzendorf's death in 1760 to stabilize the organization in Herrnhut. He spent his last years there, and retired from active work in 1791. (Courtesy of the Moravian Archives, Bethlehem.)

Peter Boehler
Boehler (1712–1775) was born in Frankfurt, Germany. He met Count Zinzendorf at the University of Jena and was greatly influenced by him. In 1737, the Moravian Church sent Boehler to America to assist the Georgia and Carolina Moravian settlements. After Boehler found the Georgia Moravians in a volatile situation, he led them to Pennsylvania to settle in Nazareth and Bethlehem. In 1748, Boehler was appointed bishop of the Moravian churches of America and Great Britain. He returned to Europe in 1764 and died in England in 1775. (Courtesy of the Moravian Archives, Bethlehem.)

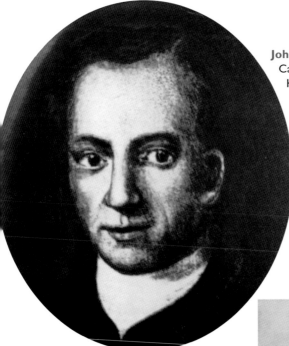

John Christoph Frederick Cammerhoff

Cammerhoff (1721–1751) was born in the town of Hillersleben, Germany. He attended the University of Jena, graduating in 1738, and became the private secretary of Count Zinzendorf. Cammerhoff married Anna von Pahlen of Liefland in 1746, and the couple had two children. He was consecrated as a Moravian bishop the same year. Cammerhoff and his wife arrived in Bethlehem in 1746, where he was Bishop Spangenberg's assistant. In 1751 he died in Bethlehem from an unknown illness. (Courtesy of the Moravian Archives, Bethlehem.)

John Martin Mack

Mack (1715–1784) was born in Wurttemberg, Germany. He arrived in America in 1735 to assist with the Moravian settlement in Georgia and traveled with the group to Bethlehem in 1741. He founded Nain and Gnadenhutten, two Native American Christian settlements near Bethlehem. In 1742, he married Jeannette Rau and was assigned to the Shecomeco mission. In 1760, Mack was sent to the West Indies to preach to the slaves of Saint Croix, Saint John, and Saint Thomas. He was married four times. (Courtesy of the Moravian Archives, Bethlehem.)

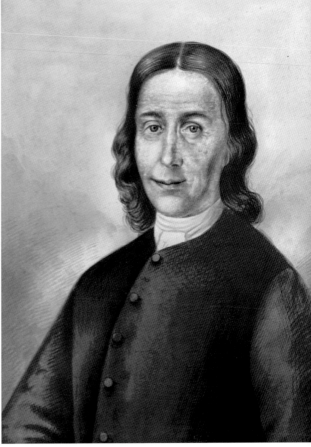

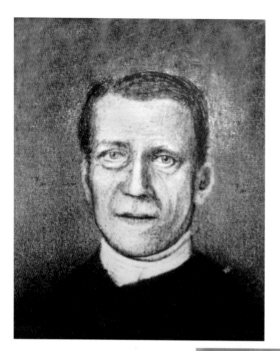

David Zeisberger
Zeisberger (1721–1808) was born in Zauchtenthal, Moravia. As a young boy, he moved with his family to the Moravian community of Herrnhut in Saxony. After completing his education, Zeisberger joined his family in settling American Moravian townsites. In 1745, Zeisberger lived among the Mohawk and became fluent in the Onondaga language. He assisted Conrad Weiser in negotiating an alliance between the English and the Iroquois in Onondaga. Zeisberger spent 62 years as a missionary among the Indians. He produced several works in Iroquoian and Algonquian. (Courtesy of the Moravian Archives, Bethlehem.)

John Gottlieb Ernestus Heckewelder
Heckewelder was born in Bedford, England, in the Moravian community of Fulneck. At age 11, he and his family sailed to America. At age 15, Heckewelder was apprenticed to a barrel maker. He lived for long periods of time with the Lenape and Mohicans, learning their language and culture. In 1786, Heckewelder moved back to Bethlehem with his wife, Sarah Ohneberg, and wrote about his years as a missionary in several publications. Author James Fenimore Cooper based his Leatherstocking Tales upon Heckewelder's writings. (Courtesy of the Moravian Archives, Bethlehem.)

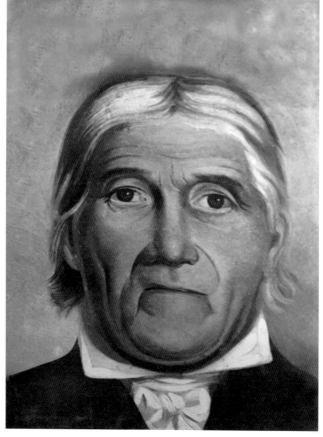

John Ettwein

Ettwein (1721–1802) was born in Wurtemberg, Germany, and moved to the Moravian community at Marienborn, Germany. Ettwein married Johannetta Maria Kymbel, and the couple traveled to England in 1751, where he learned the English language. This skill was essential to Ettwein leading the Bethlehem settlement through the Revolutionary War period. Ettwein and his family arrived in Bethlehem in 1752. He was the preacher in Bethlehem when the community accommodated the sick and wounded solders of the Continental Army. The Moravians supplied blankets, food, and medical supplies to the soldiers. (Courtesy of the Moravian Archives, Bethlehem.)

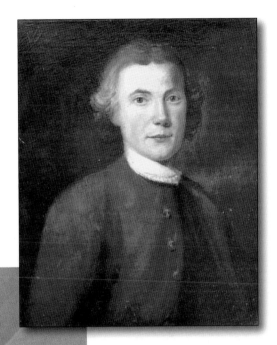

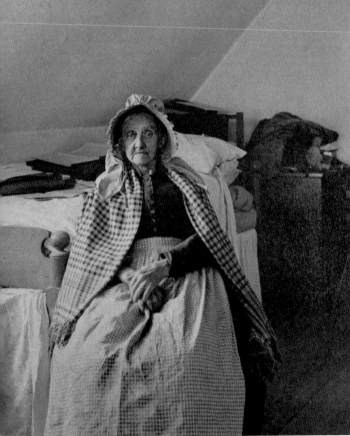

Lucy Walter

Walter (1815–1896) was born in Fountain Hill, in a blockhouse that stood where the Anthracite Building now stands. She was one of 11 children, spending her early life helping on the family farm and doing domestic duties. Walter entered the Moravian Sisters' House at the age of 20. For 60 years, she administered to the sick, making no distinction between the poor and the rich. Walter was well known and respected, having been the nurse to many distinguished families. (Courtesy of the Moravian Archives, Bethlehem.)

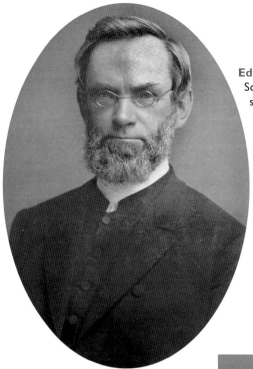

Edmund Alexander de Schweinitz

Schweinitz (1825–1887) was born in Bethlehem and studied theology at the Moravian College (1844). He taught at the boys' school, Nazareth Hall, between 1847 and 1850. Schweinitz became bishop of the Moravian church in 1870. He founded the *Moravian*, the weekly journal of his church, in 1856, and for 10 years was its editor. He was the author of several books. Schweinitz married Lydia de Tochirsky in 1850, and they had four children. Tochirsky passed away in 1868. Schweinitz married Isabel A. Boggs two years later, and they had one child. (Courtesy of the Moravian Archives, Bethlehem.)

Paul de Schweinitz

Schweinitz (1863–1940) was born in the Moravian community of Salem, North Carolina. The family moved to Bethlehem in 1867. Schweinitz was educated at Nazareth Hall, then Moravian College, graduating in 1884. He was ordained a presbyter in 1888. Schweinitz was president of the Northern Province of the Moravian Church in America. In 1887, he married Mary Catharine Daniel. The couple had four children. Schweinitz was a popular speaker and much in demand by historical societies, social clubs, and religious groups. The *New York Times* often reported on his speaking engagements. (Courtesy of the Moravian Archives, Bethlehem.)

Joseph Maximilian Hark

Hark (1849–1930) was born in Philadelphia and attended Moravian College, graduating in 1870. He was ordained as a deacon of the Moravian Church in 1873 and served as a pastor for several Moravian communities, including Lebanon, Philadelphia, and Lancaster, Pennsylvania. Hark was the principal of the Moravian Young Ladies Seminary in Bethlehem (1893–June 1909). He received a doctor of divinity degree from Franklin Marshall College in 1893. Hark was well known for his poems, essays, and other literary works. (Courtesy of the Moravian Archives, Bethlehem.)

Ann Hark

Hark (1891–1970) made her living as a reporter for the *Philadelphia Public Ledger* and the *Philadelphia Inquirer*, as a feature writer for *Ladies Home Journal*, and as the author of nine books. Her father, J. Max Hark, was head of the Moravian Seminary, where Ann graduated in 1905. She was born in Lancaster, Pennsylvania. From 1936 to 1955, Hark published nine books, the most popular of which, *Hex Marks the Spot* (1938), went through at least five printings and centered on central Pennsylvania German customs and culture. (Courtesy of the Samuels Collection.)

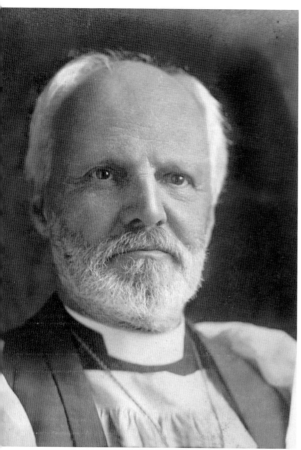

Cortlandt Whitehead

Whitehead (1842–1922), born in New York City, attended Philips Academy in Andover, Massachusetts; Yale University; and the Philadelphia Divinity School. He was ordained a deacon in 1867, a priest in 1868, and a bishop in 1882. He was a missionary in Colorado in 1867–1870 and rector of the Church of the Nativity, South Bethlehem, in 1870–1882. During his time in Bethlehem, he helped to found St. Luke's Hospital in 1873. The honorary degree of doctor of divinity was conferred on him by Union College in 1880 and by Hobart College in 1887, and he received a doctorate of sacred theology from St. Stephen's College in 1890. (Courtesy of the Moravian Archives, Bethlehem.)

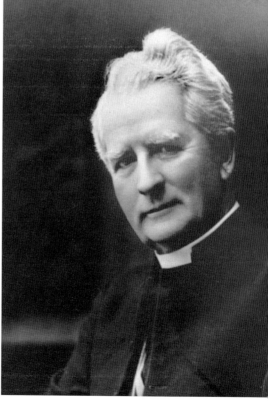

Ethelbert Talbot

Fayette, Missouri, native Talbot graduated from Dartmouth in 1870 and went to the General Theological Seminary in New York City, graduating in 1873. He was ordained in the priesthood in 1873 and immediately became rector of St. James Church in Macon City, Missouri. He built several missions in nearby towns and founded a school that became St. James Military Academy. In 1886, Talbot (1848–1928) became the first missionary bishop of Wyoming and Idaho. In 1887, the University of Missouri awarded him an honorary doctorate in law, and General Theological Seminary awarded him a doctorate in sacred theology. In 1888, Dartmouth followed with a doctorate in divinity. In 1897, he was elected the third bishop of the Episcopal Diocese of Bethlehem. (Courtesy of the Moravian Archives, Bethlehem.)

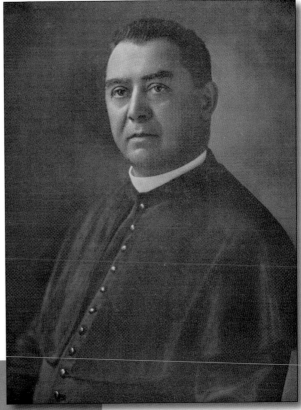

Francis C. Vlassok
Vlassok (1864–1956) was born in Bobro, Hungary. He graduated from the American College at Louvain, Belgium. By 1891, due to the large influx of Catholic Slovaks to South Bethlehem, Saints Cyril and Methodius Catholic Church was established. In 1897, he became the first rector of this church. He purchased several parcels of land around the church and sold them at low prices to parishioners. Their homes were built around the church, creating a Slovak community. In 1929, Vlassok retired due to poor health. (Courtesy of the Samuels Collection.)

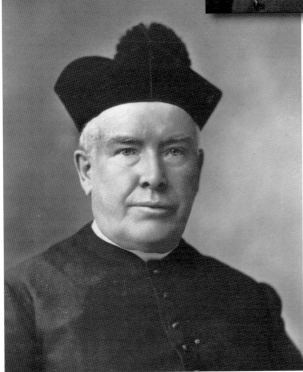

Michael Charles McEnroe
McEnroe (1835–1910) was born in Island Rock, County Caven, Ireland, part of a family of 15. He arrived in the United States in 1854 and studied in the Theological Seminary of St. Charles in Philadelphia to be ordained as a priest in 1861. He was the first clergyman to lead Holy Infancy Church in 1862, the first Catholic church in Bethlehem. In 1877, McEnroe was reassigned to a church in Manayunk, Pennsylvania, and his brother Rev. Philip McEnroe replaced him. (Courtesy of the Moravian Archives, Bethlehem.)

JESSIE WOODROW WILSON

Jessie Wilson, Francis Bowes Sayre
Sayre (1885–1972) was born in Fountain Hill in the family mansion. He attended Williams College and Harvard Law School. In 1913, he married Jessica Woodrow Wilson, the daughter of President Wilson. The couple had three children. Jessie Sayre died after an appendectomy operation in 1933, in Cambridge. In 1937, Francis Sayer married Elizabeth Evans Graves. He was appointed US high commissioner to the Philippines in 1939. He wrote several articles and books. (Courtesy of the Samuels Collection.)

Mary Elvira Strunk
Strunk (1884–1952) was born in Center Valley, Pennsylvania. She earned a teaching degree at Albright College, then taught college-level science courses. In 1918, Strunk (far right) became a missionary in Jimo, China, to supervise a Lutheran girls' school. Strunk suffered minor injuries from a Japanese bombing raid on the Chinese school and mission in 1938. After the attack, Strunk returned to Bethlehem, where she began a campaign to "Stop Arming Japan." The Chinese ambassador, Hu Shih, and the secretary of state, Cordell Hull, welcomed her visit with them in Washington, DC. (Courtesy of the Samuels Collection.)

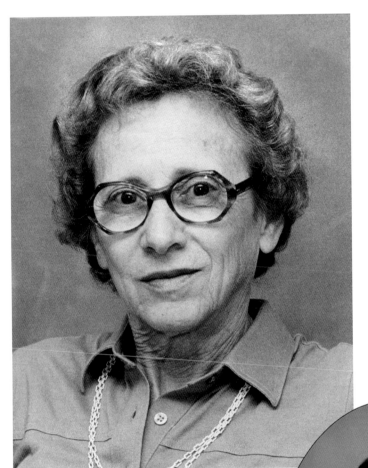

Inez Cantrell Donley
Donley (1915–2013) was born near Smithville, Tennessee, the fifth of seven children. She graduated from McKenzie School of Business. In 1943, Donley was hired as a secretary at Air Products Inc., where she met her future husband, Edward Donley, the company's CEO. They married in 1946 and raised three children. Inez Donley's work and generosity were shared between several causes. The Donleys established the Donley Foundation, a private group that issues grants for educational services for those in need. (Courtesy of the Donley Foundation.)

John Henry Kilbuck
Kilbuck (1861–1922) was born to William and Sarah (Konopot) Kilbuck in Ottawa, Kansas, on a Delaware Indian reservation. In 1884, Kilbuck was the first Native American to graduate from Moravian College and the first to be ordained a deacon. In 1885, Kilbuck married Edith Romig, and the couple built a Moravian mission, Bethel, in Alaska. They soon mastered the language of the local tribe, the Yup'ik Eskimos. The Kilbucks served as Moravian missionaries for 30 years in Alaska. (Courtesy of the Moravian Archives, Bethlehem.)

Nathan Homer Knorr

Knorr (1905–1977) was born in Bethlehem. When Knorr was 16, he first learned about the religious group the Watchtower Society. Upon graduating high school in 1923, Nathan moved to Brooklyn, New York, to work as a shipping clerk for the Watchtower Society printing plant. He eventually became president of the society. Knorr married Audrey Mock in 1953. They met in the society's printing headquarters. The Knorrs lived for over 20 years in a penthouse apartment in Brooklyn. (Courtesy of the Jehovah's Witnesses.)

John G. Gorek

Gorek (1915–2011) was born in Bethlehem. In 1930, he became involved with the Boys Club of Bethlehem as both a member and a volunteer youth leader. He remained active with the club for the next 50 years, serving as a board member and as secretary of the board. In 1971, he retired after 35 years of employment from Bethlehem Steel as chief clerk of the Standard Mills. He was married to Ida M. Gabellini for 62 years when she passed away in 2004. (Courtesy of the Steelworkers Archives.)

Ruth Evelyn Linderman Frick
Frick (1885–1979) was the great-granddaughter of Asa Packer, great-granddaughter of Robert H. Sayre, and daughter of Robert P. Linderman. Frick was the Lehigh County chair of the Woman Suffrage Party, offering her car for open-air speeches by several visiting suffrage dignitaries. Frick and others in the suffrage group went on to form the Allentown Women's Club in 1915. She married John Arthur Frick in 1908. He was the president of the Allentown- Bethlehem-Easton Gas Company. They had four children. (Courtesy of the South Bethlehem Historical Society.)

Morris Black
Black (1886–1975) was born in Russia and arrived in the United States in 1899. He married Rebecca I. Black in 1908, and they had three sons. The same year, Black started a business supplying building products to local contractors, delivering his goods by wagon. In 1943, the company added an insulation subcontracting business, one of the first in the country. In 1986, the company consolidated its operations in a new office building and warehouse complex. Black was a founder of Congregation Brith Sholom (1889) and Berkleigh Country Club (1925). (Courtesy of Brith Shalom.)

Dexter F. Baker
Baker (1927–2012) was born in Worcester, Massachusetts, and earned a graduate degree from Lehigh University. He served in the US Navy (1945–1946) and in the Army (1950–1952). In 1952, he joined Air Products and Chemicals as a sales engineer. Baker served as chief executive officer from 1986 to 1992. He married Dorothy in 1951, and they had four daughters. Their foundation continues to support numerous Lehigh Valley initiatives. The Baker Hall at Lehigh University and the Dexter and Dorothy Baker Center for Performing Arts at Muhlenberg College attest to their commitment. (Courtesy of the Samuels Collection.)

Priscilla Payne Hurd
Hurd (1919–2013) was born in Evanston, Illinois. She attended Finch College in New York City, then moved to Bethlehem in 1946 when she married George A. Hurd Sr., who worked for the legal department of the Bethlehem Steel Company. The couple had two children. In 1991, Hurd became the first woman to lead St. Luke's Hospital's board of trustees, as well the board of Moravian College. She helped create the Priscilla Payne Hurd Center, the Frank E. and Seba B. Payne Gallery, and the Priscilla Payne Hurd Chair of Moravian College. (Courtesy of the Samuels Collection.)

Frank Banko
Banko (1919– 2011) was born to Frank and Lena Banko, both Hungarian immigrants, in South Bethlehem. While Banko was a student at Lehigh in 1938, his father unexpectedly passed away, leaving him with the sole responsibility for the family business. Since then, Banko Family Distributors has become one of the leading business conglomerates in the Lehigh Valley. He married Elizabeth Gander in 1949, and they had two children. She passed away in 2001. He has generously supported many Bethlehem institutions such as Lehigh University, Liberty High School, and ArtsQuest. (Courtesy of the Banko family.)

Marlene "Linny" Fowler
Fowler (1940–2013) was born in New York City and was the daughter of the late Harold F. and Miriam (Dickey) Oberkotter. Her father was the CEO of United Parcel Service (UPS). Fowler graduated from Skidmore College in 1961 and married W. Beall Fowler, a professor of physics. They had four children. In 1966, they moved to Bethlehem when Beall joined the faculty of Lehigh University. The death of her parents left Marlene a vast inheritance. She donated over $100 million to individuals in need. She was a stained-glass artist. (Courtesy of Bob Miller.)

95

Ruth Sparks Foster
Foster (1938–2002) was born in Westfield, New Jersey. She received a bachelor's degree in chemistry from Cornell University and a master's degree in economics from Lehigh University. She taught economics for Lehigh University and was a trust fund manager for First Union Bank, Bethlehem. Foster became a member of the League of Women Voters, Bethlehem Chapter, in 1966, eventually becoming president. She was a longtime member of the Lehigh Valley Chapter of the American Association of University Women. (Courtesy of the League of Women Voters, Bethlehem Chapter.)

Pat McInerney Kesling
Kesling was born in 1944 in Westfield, New Jersey, graduating from Westfield High School in 1962. She attended West Virginia University, then worked as information director for former mayor Gordon B. Mowrer from 1974 to 1978. Kesling worked as a journalist for every major local newspaper. She was the director of development for ArtsQuest for 20 years. Kesling was instrumental in the establishment of Turning Point II, a Bethlehem shelter for victims of domestic violence. She raised $425,000 for the center, which opened in 1989. (Courtesy of the Bethlehem City Hall.)

Esther Mae Lee

Lee has been a civil rights activist in Bethlehem for the past 50 years. She is president of the Bethlehem National Association for the Advancement of Colored People (NAACP). Lee was the first black member of the Bethlehem Area School Board (1971–1977). She was born in 1934 in Bethlehem and graduated from Liberty High School in 1951. She married William L. Lee Sr., and they have two children. Lee worked as a secretary at Bethlehem Steel Corporation and has served on the board of the Bethlehem Redevelopment Authority and the Pennsylvania NAACP. (Courtesy of NACCP, Bethlehem.)

Barry W. Lynn

Lynn, born in 1948 in Harrisburg and raised in Bethlehem, graduated from Liberty High School in 1966. He began his career working at the national office of the United Church of Christ and is an ordained minister. Lynn received his bachelor's degree at Dickinson College, his theology degree from Boston University School of Theology, and his law degree from Georgetown University. From 1984 to 1991, he was legislative counsel for the Washington office of the American Civil Liberties Union. On the radio, Lynn serves as host of "Culture Shocks," a daily look at issues affecting society. In 2006, Lynn authored *Piety & Politics: The Right-Wing Assault On Religious Freedom*. In 2008, he coauthored *First Freedom First: A Citizen's Guide to Protecting Religious Liberty and the Separation of Church and State*. (Courtesy of Barry W. Lynn.)

Frank V. Loretti

Loretti served in the Navy during World War II. In 1960, he was a labor relations officer for the US Public Housing Administration in Washington, DC. Loretti arrived in Bethlehem in 1974 to fill a temporary position to manage the Bethlehem Housing Authority, and became the permanent director of the agency, serving from 1974 to 2003. Loretti married Dora Sedgwick in 1978, and they raised two children. In 1995, Loretti funded a foundation to educate all ages about diabetes. In 2001, he started Camp Red Jacket, a free day camp that has served more than 500 children with diabetes. (Courtesy of Frank V. Loretti.)

ederick A. Carlson IV Kyle J. Grimes Joshua A. Harton Christopher S. Seife

Bethlehem Heroes
The following men, shown here from left to right, gave their lives in the Iraq and Afghanistan Wars. Army Specialist Frederick A. Carlson IV, age 25, died on March 25, 2006, in Al Taqqadum, west of Bagdad, of a non-combat related cause, during Operation Iraqi Freedom. He had been in Iraq for seven months, was assigned to the 228th Forward Support Battalion, 2nd Battalion, 28th Infantry Division, Pennsylvania National Guard, based in Bethlehem. Marine Corp. Kyle J. Grimes, 21, died on January 26, 2005, while serving during Operation Iraqi Freedom. Grimes, who loved fishing, football, and learning about other cultures, and who planned a career in law enforcement, was among the 31 people killed in a helicopter crash in Iraq. Joshua A. Harton, 23, died on September 18, 2010, serving during Operation Enduring Freedom. He was assigned to the 3rd Battalion, 6th Field Artillery Regiment, 1st Brigade Combat Team, 10th Mountain Division (Light Infantry), at Fort Drum, New York. He died of wounds suffered when insurgents attacked his unit using small arms and rocket-propelled grenades in Kaftar Khan, Afghanistan. Christopher Scott Seifert, 27, died on March 22, 2003, while serving during Operation Iraqi Freedom. He was killed in a grenade attack near the Iraq-Kuwait border. Seifert was married to Theresa Flowers-Seifert. The couple's first child, Benjamin, was born in 2003. Seifert was a history major at Moravian College. (Courtesy of the Carlson, Coffin, Grimes, Harton, and Seifert families.)

Lynn Gottlieb (OPPOSITE PAGE)
Gottlieb, seen here at a Faith House Manhattan event, was born in Bethlehem in 1949. While attending high school in Allentown, Pennsylvania, she went to Israel as an exchange student. The visit inspired her to become a rabbi. She graduated from the Hebrew University in Jerusalem in 1972. In 1981, she became the first woman ordained as a rabbi in the Jewish Renewal movement. Gottlieb led a Fellowship of Reconciliation delegation to Iran in 2008, thus becoming the first female rabbi to visit Iran since the 1979 revolution. (Courtesy of Faith House Manhattan.)

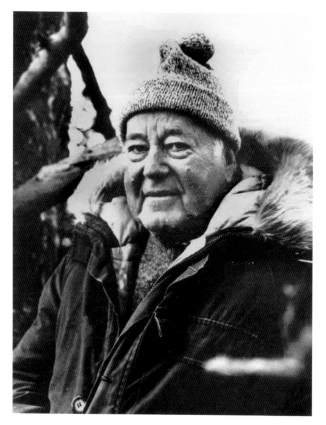

John Strohmeyer

Strohmeyer (1924–2010) was born at home in Cascade, Wisconsin, to Sylvester and Anna Saladunas. He grew up during the Great Depression and suffered abandonment and harsh poverty as a child. His mother's third marriage, to steelworker and farmer Louis Strohmeyer, finally brought stability to his life. John Strohmeyer, who never forgot the powerlessness of being poor, wrote with compassion about others in similar circumstances. Louis Strohmeyer settled the family on a farm in Nazareth, where Strohmeyer began his journalism career at age 16, reporting for the *Nazareth Item*. He joined the Navy, rising to the rank of lieutenant. Strohmeyer graduated from Moravian College in 1947 and, a year later, from the Journalism School at Columbia University in New York. He won a Pulitzer Traveling Fellowship to cover the 1948 London Olympics and the Berlin Airlift. Strohmeyer began as a reporter at the *Globe Times* newspaper in 1941. He was the editor for 28 years, from 1956 until 1984.

In May 1972, the newspaper was awarded a Pulitzer Prize for a series of Strohmeyer's editorials that focused on racial unrest in Bethlehem. He also wrote moving editorials about the demise of Bethlehem Steel. In 1984, Strohmeyer left the *Globe-Times* after winning an Alicia Patterson Fellowship. In 1986, he served as a McFadden professor at Lehigh University, from which he received an honorary doctorate degree. The following year, he moved to Anchorage, Alaska, to take the post as the Atwood Professor of Journalism at the University of Alaska, Anchorage, where he remained as writer in residence, writing columns for the *Anchorage Daily News* and fishing whenever possible. He died of heart failure at Seven Rivers Regional Medical Center in Crystal River, where he spent his winters. He wrote three books: *Crisis in Bethlehem: Big Steel's Struggle to Survive; Extreme Conditions: Big Oil and the Transformation of Alaska;* and *Historic Alaska: An Illustrated History.* Strohmeyer married Nancy Jordan, also a journalist. They had two sons and a daughter, Sarah Strohmeyer, an award-winning author. Nancy Strohmeyer died in 2000 and their son, Mark, in 1998. Strohmeyer was survived by his second wife, Sylvia Broady. (Courtesy of the Strohmeyer family.)

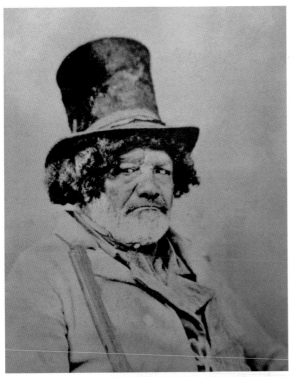

Benjamin Rice
Rice arrived in Bethlehem before 1842 and is remembered as being the first African American man to live in the area. He lived a rough life, usually sleeping in the barns that dotted the countryside. He needed a cane to steady his gait, due to the amputation of the toes on one foot after exposure to freezing temperatures. He was noted for his unusual sayings that combined English with Pennsylvania German. He said his birthday was on the Fourth of July and liked to joke that the traditional holiday jubilation was the celebration of his birthday. (Courtesy of the Moravian Archives, Bethlehem.)

Joseph T. Adams
Adams was born in 1926 in Bethlehem and graduated from Liberty High School. At age 18, he joined the US Merchant Marines and served for 48 years, 30 of those years as a captain. On Christmas Day 1978, Adams was guiding his ship, the SS *Ponce de Leon*, in the Atlantic Ocean. He came upon the shrimper boat *Ginger B*, sinking fast. Adams performed a miraculous turn to rescue the crew. He received an Admiral of the Ocean Seas award. Adams and his wife, Sue, raised five children in Bethlehem. (Courtesy of Michael Adams.)

Sandra Aguilar, Hugo Ceron, and daughter Elisa
Aguilar and Ceron met while pursuing their graduate education in the United Kingdom. They settled in Bethlehem to teach at Moravian College and Lehigh University. Aguilar and Ceron are both actively involved in community programs to assist new immigrants. Both, originally from Mexico, have chosen Bethlehem as the place to raise their children. Once again, new immigrants contribute their culture and experience to make Bethlehem a wonderful place to live. (Courtesy of the Aguilar-Ceron family.)

C. Hopeton Clennon
Clennon, born in 1960 in Jamaica, was installed as senior pastor of the Central Moravian Church in Bethlehem in 2013. He is the first person of color to hold the post. A graduate of the University of the West Indies and the United Theological College of the West Indies, Clennon migrated to the United States in 1989. Immediately before joining the pastoral staff at Central, Clennon was chaplain of Moravian College and Moravian Theological Seminary. He is married to Shelia, a teacher. They have two children. (Courtesy of the Central Moravian Church.)

CHAPTER FIVE

The Cultivators of Commerce

The Moravian Congregation of Bethlehem opened the first store in the area in 1753, selling community-produced goods, such as dried apples, gingerbread, clothing, canoes, boards, and bricks. The Moravian Bookshop, still operating today, is the oldest bookstore in the United States. It opened in 1745. By the 1900s, Main Street in Bethlehem evolved into a major shopping destination, with Riegel, Cortright & Solt Dry Goods and the Bush & Bull store. However, with the explosion of new residents on the South Side, Third Street in South Bethlehem rivaled the north for shopping. When the Bethlehems merged in 1917, the Bethlehem Chamber of Commerce was created. The chamber supported such endeavors as the building of Hotel Bethlehem (1922), the first luxury hotel in the area, and popularizing Bethlehem as a Christmas tourist destination (1937). The successful businesspeople in this chapter are also the most generous people one could hope to meet. They have made the community a better place in which to work and live.

In his 2012 State of the City address, Mayor John B. Callahan said:

While we work on the business of being a city, we cannot forget our duty to drive economic expansion in the City. With our eyes to the future, understanding the realities of today, we will reach our destination, to be the model for the transformation of an old industrial town into a modern, dynamic city, competitive in the 21st century and the place everyone wants to live, work and visit.

Timothy Horsfield

Horsfield (1708–1773) was born in Liverpool, England. In 1725, he immigrated to Long Island, New York, where his brother Isaac taught him the butcher's trade. He married Mary Doughty in 1731. The couple had eight children. The family moved to Bethlehem in 1749, into the first private home permitted by the Moravian community. The addition built on the home in 1753 was used as the first store in the Lehigh Valley. Horsfield was named justice of the peace when Northampton County was formed out of Bucks County in 1752. (Courtesy of the Moravian Archives, Bethlehem.)

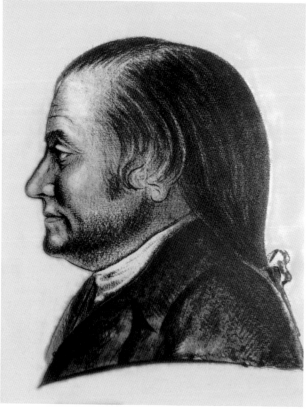

Ernest F. Bleck

Bleck (1806–1880) a community leader, educator, and musician, helped to guide the transition of Bethlehem from a village to an incorporated borough in 1845. Bleck was born in Graceham, Maryland. Upon completing his education at Nazareth Hall in 1818, Bleck stayed on to teach and study divinity at the Theological Seminary. In 1831, Bleck married Christianna H. Barnitz. In 1837, the couple and their daughter moved to Bethlehem, as the Moravian community leaders encouraged Bleck to open the Bethlehem Institute for Boys. It was the first preparatory school in Bethlehem. (Courtesy of the Moravian Archives, Bethlehem.)

Augustus Wolle
Wolle (1821–1878) organized the Saucona Iron Company, which eventually became the Bethlehem Iron Company. He was born in Nazareth and moved to Bethlehem as a young child. At 24, Wolle bought the congregation's general store and became the proprietor. He sold dry goods, groceries, gifts, and exquisite music boxes. In 1852, Wolle, his brother Francis, and other partners started the Union Paper Bag Machine Company. He was one of the founders of the First Bank of Bethlehem and was secretary of the Lehigh & Lackawanna Railroad Company. Wolle organized the Chapman and Pennsylvania Slate Companies. (Courtesy of the Moravian Archives, Bethlehem.)

Jacob Luckenbach
After the Moravians dissolved their General Economy, they sold their mill to Charles A. Luckenbach in 1845. Charles sold it to his cousin, Jacob Luckenbach (1805–1888), in 1847. Jacob was the first private operator of a mill on that site since 1743. Luckenbach married Mary Whitsell, and they had nine children. He retired from the mill business in 1861 and sold it to his sons, David and Andrew. Luckenbach served on the borough council in 1846 and played in the Bethlehem Band. (Courtesy of the Moravian Archives, Bethlehem.)

Asa Packer

Packer (1805–1879) was born in Mystic, Connecticut. As a teenager, he moved to Pennsylvania to learn carpentry. Packer believed a railroad would be more efficient than canal transportation and became the majority stockowner of the Lehigh Valley Railroad in 1855. He selected South Bethlehem for the headquarters. Packer founded Lehigh University (1866) and St. Luke's Hospital (1872). He served in the Pennsylvania House of Representatives (1841–1842) and as a county judge of Carbon County (1843–1848). Packer was married to Sarah Minerva Blakslee, and they had seven children. (Courtesy of the Moravian Archives, Bethlehem.)

Robert Heysham Sayre

Sayre (1824–1907) was born near Bloomsburg, Pennsylvania, and moved with his family to Jim Thorpe, Pennsylvania. Sayre was vice president of the Lehigh Valley Railroad as well as vice president of Bethlehem Iron Works. Sayre was married four times, due to early deaths of his first three wives. He first married Mary Evelyn Smith. They had nine children. Next, Sayre married Mary Bradford, then Helen Augusta Packer, and finally Martha Finley Neven. The fourth marriage produced three children. (Courtesy of the Moravian Archives, Bethlehem.)

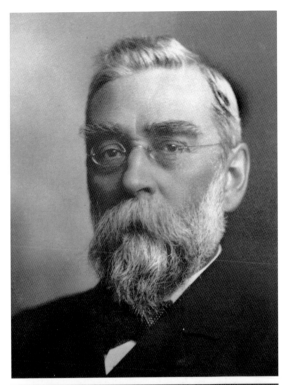

Elisha Packer Wilbur
Wilbur (1833–1910) was born in Mystic, Connecticut. He moved with his parents to Jim Thorpe and found his first job in the general store of Asa Packer, his uncle. He became Packer's secretary until Packer's death in 1879. Wilber moved to Bethlehem in 1859 and became president of the railroad, until it was sold in 1893. Wilbur was a member of South Bethlehem's first town council and was the chief burgess from 1869 to 1874. He married Stella Mercer Abbott of Bethlehem. The couple had seven children. (Courtesy of the Moravian Archives, Bethlehem.)

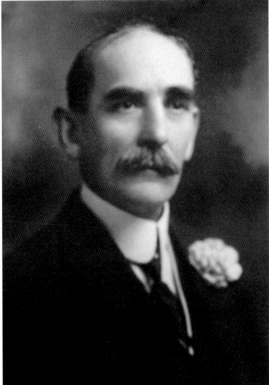

Warren Abbott Wilbur
Wilbur (1859–1932) was born in Bethlehem and attended Swarthmore College. In 1877, he began employment at the Bethlehem Iron Company, in charge of the Lucy Furnace at Glendon. In 1880, Wibur joined his father, E.P. Wilbur, in the banking business. He served as treasurer of the borough of South Bethlehem and was active in the chamber of commerce. Wilbur married Sallie P. Linderman, and they had one son. His second wife was Kate Ellen Brodhead, whom he married in 1901. (Courtesy of the Moravian Archives, Bethlehem.)

Joseph Wharton

Wharton (1826–1909) was born in Philadelphia. In 1853, he visited the zinc mines at Friedensville and, soon after, Wharton, his brother Charles, and associates bought the controlling interest in the Pennsylvania & Lehigh Zinc Company in South Bethlehem. Wharton guided the company to becoming the first successful producer of zinc in the United States. He married Anna Corbit Lovering in 1854, and they had one daughter. Wharton endowed the University of Pennsylvania to found the first American college of business in 1881. (Courtesy of the Moravian Archives, Bethlehem.)

Garret Brodhead Linderman

Linderman (1829–1885) was born in Lehman Township, Pennsylvania. He received a medical degree from the College of Physicians and Surgeons in New York City. Linderman came to Jim Thorpe during the 1853 cholera epidemic. He subsequently became involved in the financial ventures of his father-in-law, Asa Packer. In 1870, he moved to South Bethlehem to manage the Lehigh Valley National Bank and the Bethlehem Iron Company. Linderman was married to Lucy Packer, and the couple raised three children. After Lucy's death, Linderman married Frances Evans, and they had three children also. (Courtesy of the Moravian Archives, Bethlehem.)

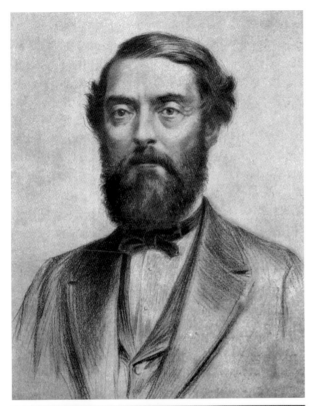

Edwin Laurentine Drake

Drake, also known as Colonel Drake (1819–1890), was born in Greenville, New York. He was hired by the Seneca Oil Company to secure property in Titusville, Pennsylvania. Drake designed a drill that successfully brought up oil on this property in 1859. He launched the modern petroleum industry in the United States, but never patented his drill. In 1873, the Pennsylvania Congress voted to give Drake and his wife an annuity of $1,500, in gratitude for his invention. Drake spent the last years of his life in Bethlehem, confined to a wheelchair. (Courtesy of the Samuels Collection.)

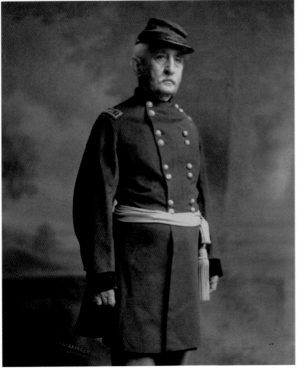

William Emile Doster

Doster (1837–1919) was born in Bethlehem and attended Yale College and Harvard Law School. During the Civil War, Doster was promoted to brigadier general. At the trial of the Lincoln assassination conspirators, Judges Joseph Hold and John Bingham appointed him to defend Lewis Payne and George Atzerodt. Both were convicted and hanged. Doster returned to Bethlehem and resumed his law practice at Easton. In 1867, he married Evelyn A. Depew and they had three children. Evelyn passed away, and Doster married Ruth Porter in 1888, and the couple had four children. (Courtesy of the Moravian Archives, Bethlehem.)

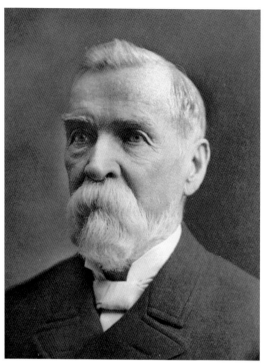

John Fritz

Fritz (1822–1913) was born on the family farm in Londonderry Township, Chester County. At age 16, he left to work as an apprentice in a blacksmith and machinist shop. In 1844, iron mill owners Moore and Hooven hired him as a machinist. Fritz came to Bethlehem in 1860 as chief superintendent of Bethlehem Iron Company. He led the company into steelmaking. He married Ellen W. Maxwell in 1851, and they had a daughter. (Courtesy of the Moravian Archives, Bethlehem.)

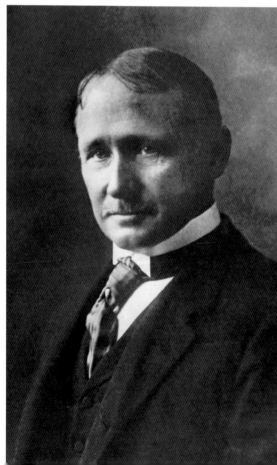

Frederick Winslow Taylor

Taylor (1856–1915) was born in Germantown, Pennsylvania, to an upper-class Quaker family. He earned an engineering degree at the Stevens Institute of Technology, and arrived at the Bethlehem Iron Company in 1898 at the request of Joseph Wharton. Taylor was a pioneer in the field of engineering consultation and is considered "The Father of Scientific Management." However, Taylor's cold scientific approach affected employee morale negatively and obstructed production. He was discharged in 1901. Taylor married Louise Spooner in 1890, and they adopted three children. (Courtesy of Steelworkers Archives.)

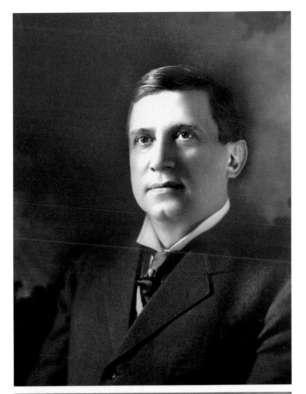

Charles M. Schwab
Schwab (1862–1939) was born in Williamsburg and raised in Loretto, Pennsylvania. He attended Saint Francis University and began his career as an engineer at Carnegie Steel Company in 1897. In 1903, he became the president of the Bethlehem Steel Company. Under his leadership, it became the second-largest steel producer in the world. Schwab married Emma Eurana Dinkey in 1883. He had one daughter with a mistress. Schwab lived a fast life, spending most of his fortune, estimated at between $25 million and $40 million, before his death. (Courtesy of the Moravian Archives, Bethlehem.)

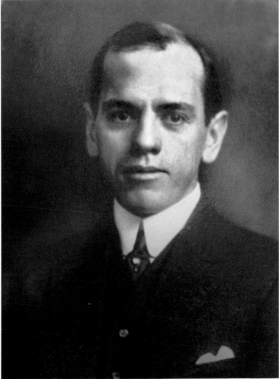

Eugene Gifford Grace
Grace (1876–1960) was born in Goshen, New Jersey. In 1899, he graduated from Lehigh University. He was the shortstop of Lehigh's baseball team. The National League's Boston Braves tried to recruit him, but Grace took a job as a crane operator for the Bethlehem Steel Corporation. By 1913, he was president of the company, retiring in 1957 as chairman of the board after 33 years of service. In 1902, Eugene Grace married Marion Brown, daughter of a former South Bethlehem burgess, Charles F. Brown. They had three children. (Courtesy of the Moravian Archives, Bethlehem.)

Anthony Goth
The Goth family emigrated from Austria to the United States in the mid-1800s. The Goth brothers left behind their Catholic upbringing and adopted the Moravian religion as their own. The brothers were exceptional sign and fresco painters. The most accomplished was Anthony Goth (1824–1878). He was selected by the Pennsylvania legislature to paint frescoes on walls and ceilings in the Pennsylvania Capitol building. Goth arrived in Bethlehem with his wife, Maria Anna Nowitsky. They had 11 children. Nowitsky died in 1868. Goth married Eleanor Sophia Lichtenthaaler, a teacher. (Courtesy of the Moravian Archives, Bethlehem.)

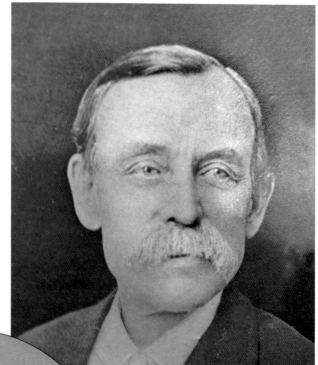

Charles H. Groman
Groman (1862–1940) was born in Allentown and moved with his parents to South Bethlehem. He joined the family contracting and bricklaying business, Groman Brothers, which was the largest brick manufacturer in Bethlehem. The company built the Anthracite Building, Central High School, Allentown State Hospital, the Ingersoll-Sargent Company building in Easton, and numerous private residences. Groman was a city councilman for nine years and served as treasurer of Northampton County from 1899 to 1902. He was a founding member of the Lehigh Hook & Ladder Company in 1884. (Courtesy of the Moravian Archives, Bethlehem.)

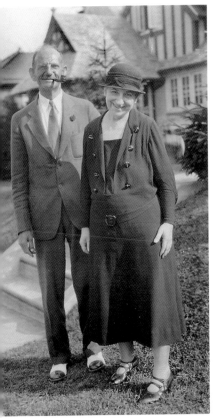

Meyer Bayuk and Julia Mann Bayuk
The history of the cigar-making Bayuk brothers begins in 1896, when Sam, Max, and Meyer Bayuk pooled $325 and opened their first factory in a rented Philadelphia attic. In 1908, the Bayuk Brothers Company rented the old skating rink at the corner of Chestnut Street and Broadway in Bethlehem as a facility to manufacture their well-known "Havana Ribbon" cigar. They soon outgrew the space, and by 1912, they built a factory on Fourth Street. The factory employed 400 people. Meyer Bayuk (1874–1971) came to the United States with his family from Russia at the age of three. Bayuk would eventually serve as treasurer and chairman of the board of the family company until his retirement in 1925, when the company was the largest independent cigar maker in the country. (Courtesy of the Samuels Collection.)

Samuel Born, Jack Schaffer, and Irv Schaffer
Born (1891–1959), originally from Russia, immigrated to the United States from France in 1910. In 1923, he married Anna C. Shaffer, opened a small chocolate shop in Brooklyn, New York, and invited his brothers-in-law Jack and Irv Shaffer to become his partners. A sign reading "Just Born" in the shop window to announce a fresh batch of chocolates led to the company name, Just Born. Outgrowing its New York headquarters, the company moved to an empty factory in Bethlehem in 1932. (Courtesy of the Just Born Company.)

Charles F. Kurtz

The theater now known as the Boyd opened on September 1, 1921, as the Kurtz Theatre. The newest and largest theater in Bethlehem, the Kurtz was the dream of Charles and John Kurtz, local businessmen who owned a successful cabinetry and furniture-manufacturing business. They also owned the Kurtz Restaurant, located in the same building as the theater. Charles F. Kurtz (1872–1949) was born in Metzingen, Germany, and immigrated to the United States at the age of 17. He and his brother, John, started the furniture business in 1894 in Bethlehem. (Courtesy of the Moravian Archives.)

Walter J. Dealtrey

Dealtrey (1928–2002), born in Miami, Florida, served in the Army during World War II. He received a bachelor's degree in business from Syracuse University in 1952. He was the founder of the Service Tire Truck Center chain, started in 1955 in South Bethlehem. Although one of his biggest customers was Bethlehem Steel Corporation, Dealtrey foresaw a time when the survival of the Lehigh Valley would depend upon the diversification of businesses and the construction of efficient highways to attract such businesses. He successfully helped to establish the Lehigh Valley Industrial Park and the Route 22 bypass, also known as I-78. This stretch of the highway was named the Walter J. Dealtrey Memorial Highway, in his honor, in 2004. (Courtesy of the Samuels Collection.)

Arthur Victor Aykroyd and Edith M. Aykroyd
Aykroyd Hardware was founded by Arthur and Edith Aykroyd in 1954 as a retail hardware store serving the Lehigh Valley. It was a place for the locals to spend an afternoon socializing. Arthur Aykroyd (1909–1986) was born in New York and moved to South Bethlehem as a young boy. His father, George, was the superintendent of the Saucon Plant at Bethlehem Steel Corporation. Aykroyd attended Liberty High School and began his career as a radio repairman. He married Edith Diane Meckes, and they had three children. Upon Aykroyd's death in 1985, his grandson, Peter Mickolay, assumed ownership and moved the store to its current location on New Street. (Courtesy of the Mickolay family.)

John F. Stefko
Stefko (1886–1961) arrived in America at age 16 from Slovakia in 1901. He worked in the mills of the Atlas Cement Company at Northampton, then came to South Bethlehem to work for the Michael O'Reilly clothing company. He was a recruiter for Bethlehem Steel during World War I. After attending the South Bethlehem Business College, he became a banker and wholesale liquor store distributor. He purchased the Minsi Trail Farm and constructed 1,600 homes. He was appointed to the first board of the Bethlehem Housing Authority in 1938. In the late 1940s, Stefko offered to bulldoze a road between the Minsi Trail Bridge and Easton Avenue if the city would blacktop it. The highway was finished in the mid-1950s and was named Stefko Boulevard. (Courtesy of the Samuels Collection.)

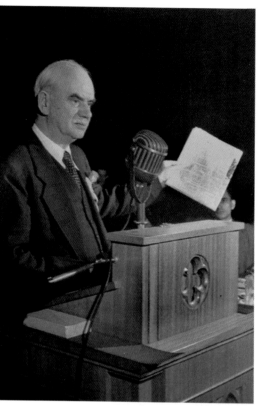

Philip Murray

Murray (1886–1952), president of the United Steel Workers of America, is seen here speaking to the striking Bethlehem steelworkers on Sunday, October 16, 1949. Over 7,000 steel men and their families filled the Liberty High School stadium to hear their union leader speak. Murray had called for the strike of more than 500,000 workers in the steel industry on October 1. The union's prominent issue was that employers should fund employee pensions and social insurance (medical insurance). The nation's steel plants came to a stop. An agreement was reached by the end of the month, giving the employees contributions to their pensions and health insurance. (Courtesy of the Samuels Collection.)

Jerry Green

Green has been the president of Steel Workers Union, Local 2599, since 2000. He is the longest-serving leader of Local 2599 in its history, which was chartered by the United Steel Workers in 1942. Green was employed at the Lehigh Heavy Forge Corporation plant in Bethlehem before being elected to lead Local 2599. Green has been a member of the United Steelworkers since 1976. Before becoming president, he served on the grievance committee just as Bethlehem Steel declared bankruptcy. Green helped thousands of steelworkers hang on to their benefits at the lowest point in US steel-manufacturing history. (Courtesy of Jerry Green.)

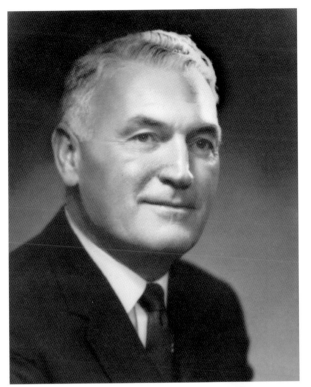

Frank L. Marcon
Marcon (1905–1982) started his Bethlehem plastering business, Duggan and Marcon, in 1929. The business today is owned and run by second- and third-generation family members. Marcon was president of the Bethlehem Chamber of Commerce and a man of great vision. In 1959, he became president of a new organization called Lehigh Valley Industrial Park Inc. The organization purchased four parcels, 226 acres located within Bethlehem. Marcon campaigned for area businessmen and banks to raise the funds for the land. The businesses located there would offer much-needed jobs after the demise of Bethlehem Steel. He served on the DeSales University board of trustees from 1966 until his death in 1982. (Courtesy of the city of Bethlehem.)

Arthur Bartlett Homer
Homer (1886–1972) showed an early proclivity toward building machines. He attended the Rhode Island School of Design and Brown University. Homer entered the Navy Submarine Service in 1918, and in 1921, became manager of diesel engineering and sales at Bethlehem Steel. He became president of Bethlehem Steel in 1945 and chief executive officer in 1957. Homer was the highest-paid US business executive in 1958. In 1961, Bethlehem Steel Company named their new research center, built on top of South Mountain, after Homer. (Courtesy of the Moravian Archives, Bethlehem.)

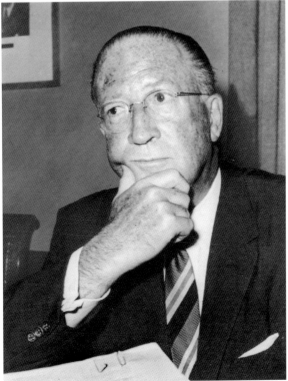

Edmund Fible Martin
Martin (1902–1993) joined the Bethlehem Steel Corporation in 1922 after graduating from the Stevens Institute of Technology. He began in the Saucon Division and, in 1958, was promoted to vice president of the steel division. In the 1960s, Sweden, Liberia, and Brazil conferred awards to Martin for his management of foreign steelworks. Martin oversaw the construction of Martin Tower, the central headquarters for Bethlehem Steel from 1972 to 2001. He was a trustee of Lehigh University and St. Luke's Hospital. He married Frances Taylor, and they had two daughters. (Courtesy of the Steelworkers Archives.)

Lewis W. Foy
Foy (1915–2009) was born on a farm in Shanksville, Pennsylvania. In 1936, he started at Bethlehem Steel Corporation as an accountant. At the outbreak of World War II, Foy enlisted in the Army, rising to the rank of captain. He married his longtime sweetheart from Johnstown, Marjorie Werry. After the war, Foy returned to Bethlehem Steel and moved rapidly up the ranks, from assistant buyer to chairman and CEO (1974–1980). In 1982, Moravian College dedicated the Foy Concert Hall in his honor. The Foys had two daughters. (Courtesy of the Steelworkers Archives.)

Curtis H. Barnette
Barnette was born in 1934 in St. Albans, West Virginia. He graduated from West Virginia University in 1956, then became a Fulbright Scholar, studying international law at Manchester University in England. From 1957 to 1959, he served as a counterintelligence officer for the US Army in Frankfurt, Germany. He graduated from Yale Law School in 1962. Barnette joined Bethlehem Steel Corporation as an attorney in 1967 and was elected the company's chairman and CEO, serving from 1992 to 2000. Barnette married Joanne Harner in 1957, and they have two sons. (Courtesy of the Steelworkers Archives.)

Dorothy L. Stephenson
In 1996, Stephenson was the first woman appointed to a management position in the 90-year history of Bethlehem Steel. She joined the firm as a labor attorney in 1976. In 1994, Stephenson was appointed manager of human resources at Bethlehem Structural Products. Stephenson was born in 1949 in Carlisle, Kentucky. She graduated from the University of Kentucky and the University of Louisville. Following a 27-year career at Bethlehem Steel, Stephenson became senior vice president of human resources at Visteon Corporation, in Van Buren Township, Michigan. (Courtesy of Steelworkers Archives.)

Lee Iacocca

Iacocca is the former chief executive officer and chairman of the board of Chrysler Corporation (1978–1992). His greatest achievements at Chrysler included development of the original "minivan" vehicle platform and engineering of the bankruptcy rescue of the company. Before his time at Chrysler, Iacocca spent 32 years with Ford Motor Company, rising from management trainee to president and chief operating officer. Lee (Lido Anthony) Iacocca was born in 1924 in Allentown. He graduated from Lehigh University and Princeton University. Iacocca married Mary McCleary in 1956. They had two daughters. (Courtesy of Lee Iacocca.)

John E. McGlade

McGlade was born in 1954 in Bethlehem. He attended Liberty High School and Bethlehem Area Vocational Technical School and graduated from Lehigh University with a degree in industrial engineering in 1976 and an MBA in 1980. He was appointed president and chief executive officer of Air Products in 2007 and chairman of the board in 2008. He married Brenda J. Miller, and they raised their family in Allentown. (Courtesy of Air Products.)

Elmer D. Gates
Gates was born in 1929 in Blue Mountain Lake, New York. After graduating from Clarkson College, he served in the US Army Corps of Engineers during the Korean conflict. Gates had a 31-year career with General Electric prior to joining Fuller Company, a manufacturer of equipment for the cement industry. Under his direction as CEO, the company flourished to become a world leader in the industry. He is a founding director of Embassy Bancorp Inc. and the Ambassador Bank. He married Betty Spriggs, from Syracuse, New York, in 1953. They raised two daughters. (Courtesy of the Samuels Collection.)

Raymond A. "Chip" Mason
Mason was born in 1938 in Lynchburg, Virginia, and grew up in Bethlehem, his family moving there following his father's death. Mason returned to Lynchburg in 1959 after graduating from the College of William and Mary to work at his uncle's brokerage firm. At age 25, Mason founded the investment firm Legg Mason in Newport News, Virginia. It is now the fifth-largest investment house in the United States. He married Rand Riviere, and they have six children. (Courtesy of Legg Mason.)

Louis P. Pektor III
Pektor was born in 1951 in Lower Saucon Township. He graduated from Moravian College in 1972 and from Lehigh University in 1973. Pektor started Ashley Development Corporation in 1989. The firm is known for building mixed-use projects. Pecktor renovated the landmark buildings of Main Street Commons, St. Luke's at Union Station, Riverport, and One East Broad Street, bringing new businesses and residents to the city. Ashley Development received the 2007 Small Business Council Excellence in Business Award. Pektor is married to Melissa E. Shelly. His daughters, Amy and Lisa, manage many of the company's projects. (Courtesy of Ashley Development Corporation.)

Julio A. Guridy
Guridy was born in 1960 in the Dominican Republic. His family settled in Bethlehem when Guridy was 15. He graduated from Freedom High School, East Stroudsburg University, and Indiana University of Pennsylvania. Guridy has served on Allentown City Council for 12 years, currently as president. He has received numerous awards over the years, such as the Outstanding Dominican American by the president of the Dominican Republic, and the Human Relations Award by Allentown Human Relations. He is married to Mercedes Guridy, and they have three children. (Courtesy of Julio A. Guridy.)

Vernon K. Melhado

Melhado (1889–1938), an immigrant from Jamaica, was a graduate of University of Oxford. Melhado owned several large plantations in Jamaica. As president of the chamber of commerce, Melhado thought of a new way to attract tourists during the Great Depression. In 1937, the city was promoted as the "Christmas City." The shopping districts were decorated with lights, and a large illuminated wooden star was erected on the top of South Mountain. Melhado married Mary Taylor Snyder in 1920, and they had three children. (Courtesy of the Samuels Collection.)

Tony Iannelli

Iannelli was born in 1953 in Allentown and attended Allen High School. He started his career at Mack Trucks on the assembly line, and his natural leadership abilities brought him to positions of greater responsibilities. One of his dreams was to unify several small chambers into a Lehigh Valley chamber of commerce. In 1997, he succeeded in this task and became the president of the Greater Lehigh Valley Chamber of Commerce. He is also the host of *Business Matters* on television station WFMZ and a USA Hockey referee. He has raised two daughters. (Courtesy of Tony Iannelli.)

Emile Diebitsch

Diebitsch (1867–1949) was born on the family farm in Forestville, Maryland. He graduated from Lehigh University in 1889. Upon graduation, Diebitsch expected a long career in civil engineering. His older sister, Josephine, however, had different plans for him. Josephine married Lt. Robert E. Peary in 1888, and Diebitsch accompanied Peary and his sister on expeditions to Greenland in 1893 and 1895. He formed a contracting company, which built Grand Central Terminal in 1913. Diebitsch served as mayor of Nutley, New Jersey, from 1916 to 1920. In 1906, he married Roberta Franc Watterson, a literary writer and librarian. (Courtesy of the Nutley City Hall.)

James Sitgreaver Cox

Cox (1918–2011) was born in Philadelphia and attended the University of Pennsylvania, graduating in 1939. He served in the US Army during World War II and was awarded the Bronze Star. Cox retired as a lieutenant colonel from the Army Reserve in 1955. He was superintendent of the forging division at the Bethlehem plant, retiring after a career of 42 years with Bethlehem Steel Corporation. It was under his direction that the last armor-plate production took place. He married Ruth S. Cox in 1941, and they had four children. (Courtesy of the Steelworkers Archives.)

Neville Gardner

Gardner, a native of Lamberg in Northern Ireland, is owner of Donegal Square, a shop in downtown Bethlehem specializing in authentic Irish and British goods. He graduated from Queens University in Belfast, Ireland, with a degree in civil engineering in 1978. Gardner is the chair of the Downtown Bethlehem Association board. He was the technical director for the hockey tournament with the US Olympic Committee in 1983. Gardner was a founder of the North American Celtic Trade Association (NACTA). He cofounded the yearly Celtic Classic in 1987 and the annual Harvestfest in Bethlehem. Gardner supports the Animal Health and Welfare Shelter with the annual Celtic Breeds Doggie parade. Gardner is married to attorney Linda Shay, and they have a son. (Courtesy of Celtic Classic.)

Robert DeSalvio

DeSalvio was born in New Jersey and graduated from the University of Denver, Daniels College of Business, in 1978. He started his career at the Caesars Sands Casino in Atlantic City as a senior manager and has been president of Sands Casino since 2006. He oversaw the transformation of the old Bethlehem Steel site into the Sands complex, which includes the casino, a 300-room hotel, an event center, and an outlet mall. The casino opened its doors in 2009. DeSalvio is responsible for bringing to Bethlehem thousands of jobs and making the South Side a destination. He has created partnerships with Northampton Community College, ArtsQuest, Discover Lehigh Valley, and the Greater Lehigh Valley Chamber of Commerce. He is married to Frances E. DeSalvio. (Courtesy of Sands Casino Resort Bethlehem.)

INDEX